IMAGES
of America

CATASAUQUA AND NORTH CATASAUQUA REVISITED

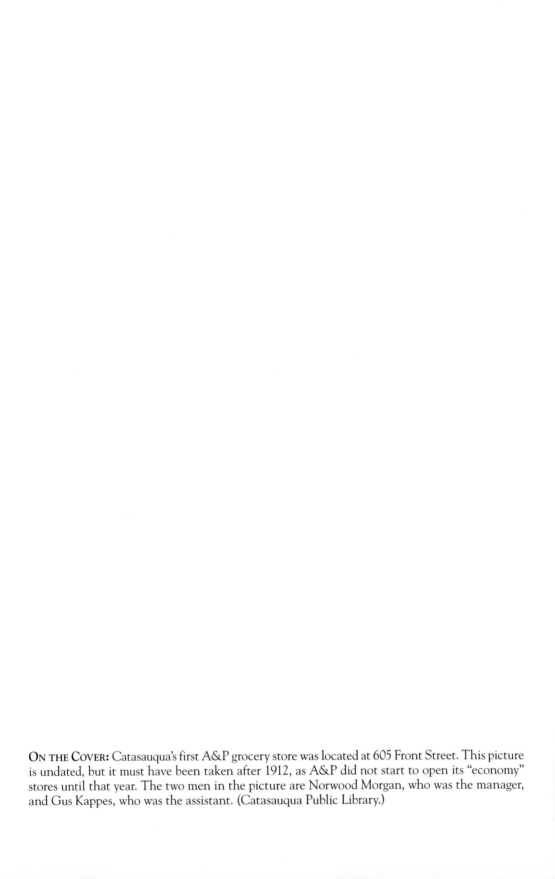

ON THE COVER: Catasauqua's first A&P grocery store was located at 605 Front Street. This picture is undated, but it must have been taken after 1912, as A&P did not start to open its "economy" stores until that year. The two men in the picture are Norwood Morgan, who was the manager, and Gus Kappes, who was the assistant. (Catasauqua Public Library.)

IMAGES
of America

CATASAUQUA AND NORTH CATASAUQUA REVISITED

Martha Capwell Fox

ARCADIA
PUBLISHING

Published by Arcadia Publishing
Charleston, South Carolina

Printed in the United States of America

Library of Congress Control Number: 2010942493

For all general information, please contact Arcadia Publishing:
Telephone 843-853-2070
Fax 843-853-0044
E-mail sales@arcadiapublishing.com
For customer service and orders:
Toll-Free 1-888-313-2665

Visit us on the Internet at www.arcadiapublishing.com

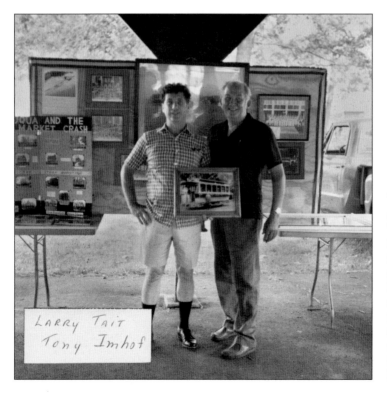

This book is dedicated to Larry Tait (left) and Tony Imhof Jr. Without their dedication, enthusiasm, and hard work, we would not have many of the pictures and artifacts that tell the stories of our towns. (Catasauqua Public Library.)

CONTENTS

ACKNOWLEDGMENTS

Both the Catasauqua Public Library and Historic Catasauqua Preservation Association (HCPA) put their photographs, ephemera, and artifacts at my disposal. It would not have been possible to compile this book without their willingness to share their collections. Bob LeFevre's massive labor of love in scanning all 1,200 or more of HCPA's slides onto disks made it possible to search their pictures easily, while the enthusiastic cooperation of Martha Birtcher, the library's director, and Deborah Mellish, president of HCPA, gave me access to everything I wanted. By extension, thanks to everyone who has donated materials to each of these organizations over the years.

Thomas Moll, director of student affairs at Catasauqua High School, was a fountain of information about athletics at Catty High. Rick and Kathy Geiger pulled out albums of pictures from the Catasauqua Club. After working on Catasauqua history for more than 25 years, I did not think it was possible that there was a picture I had never laid eyes on, but Faye Westover proved me wrong with her never-before-seen picture of 216 Church Street. Larry Tait was also a great source of information and allowed me to use the excellent photographs of his former coworkers at Phoenix Forging.

Finally, my most sincere thanks to Ray Smicker of Silver Images. Without his incredible generosity in sharing both his time and his technical expertise, this book would never have happened.

INTRODUCTION

The picture on page 10 is an illusion. It shows the Crane Iron Works and the Lehigh Canal, apparently in fine shape—smoke rising from the smokestacks, the canal banks sharply defined, the train tracks gleaming from constant traffic. But when this picture was taken around 1920, the future was bearing down ominously on both the ironworks and the canal. Steel had superseded iron in almost every way. Those shining rails almost shout "Faster!" as they run by the placid waters of the canal. Though it was taken 20 years into the 20th century, this picture is really the last look at 19th-century Catasauqua.

The cracks in the foundation of the iron business had been growing for some time, but the demand for war materials had given the industry a brief reprieve. The years following World War I saw an outright depression in the iron industry. The Empire Steel and Iron Company—the Crane Iron Works' parent—like nearly all East Coast iron businesses, could not compete with the bigger American steel companies and foreign competition. Leonard Peckitt, Empire's owner, tried to stave off the inevitable with a series of consolidations and reorganizations, but by August 1924, the company was completely owned by Replogle Steel Company. Iron production in Catasauqua ended some time in the 1920s; the 1953 centennial commemoration book *Our Town* places it as early as 1921. By 1930, the last two furnaces were pulled down and sold for scrap.

But as bad a blow as that was, we know it was not the end of Catasauqua. A few years after the ironworks' site was cleared, the Fuller Company purchased most of it and began in-house production of its world-famous Fuller-Kinyon pump and other apparatus for the cement industry. In North Catasauqua, the Phoenix Horse Shoe Company of Poughkeepsie, New York, bought out its rival, the Bryden Horse Shoe Works, and began to consolidate all its manufacturing operations on Front Street. The other forging company, the Davies and Thomas on Race Street, actually moved into its biggest boom times during the 1920s and 1930s, turning out tunnel sections for some of the biggest public works projects in the United States, such as the Holland Tunnel.

Even one of the biggest-ever failures in the American silk industry—the collapse of D.G. Dery's empire in 1923—did not impact the textile business in Catasauqua for long. Other companies moved into Dery's mill on Race Street, and businesses in that mill, the former Wahnetah mill on Lehigh Street, and the former Unicorn mill on upper Front Street continued to turn out fabrics and ribbon into the 1970s.

So life and work in Catasauqua changed. If the town was less prosperous than before, it was more pleasant. While the iron furnaces had been the driving engine of the town's economy for 80 years, they had also been noisy, smoky, and sooty. Many of the tiny company houses that had been packed with single male tenants became cherished, privately owned family homes instead. The churches stayed full, and the schools—both public and parochial—became an even stronger focus of the communities' life than they had before. And like other Americans, residents' desire for consumer goods grew as the variety of things available to buy increased, which led to an even greater array of retail stores than had existed 20 or 30 years before.

This volume about Catasauqua and North Catasauqua focuses on life in our communities during the 20th century, from the 1920s to the 1990s. The previous book about the towns in the Images of America series does contain many pictures from this same time period, but its chief focus was on the period that led up to the "Million Dollar Town" era. A few of the images here dip back into those years. They are included because they have been discovered since the previous book was published and are too significant and/or too wonderful not to be seen. (The pictures that do not have credits following the captions are either from the author's collection, or were lent by residents who did not wish to be acknowledged.) As with the previous books, there are some obvious omissions, but as before, that is because either there were no photographs available or what was found did not meet the publisher's quality standards.

In many ways, this book is more about people than places compared to the first volume. Not only most of the places but also many of the people pictured here are still with us. Especially in the final chapter, this is a community photograph album. It should remind us that, although keeping our historic houses, buildings, and places viable is important for preserving our heritage and our sense of place, it is the people who provide the living spirit of our communities.

One

NEW CENTURY, NEW INDUSTRIES

Catasauqua's golden age of iron ended early in the 20th century, but a fairly diverse collection of industries existed for many years afterwards. Until the 1970s, silk and other textile weaving remained a major source of employment, especially for women. The industry in Catasauqua fell prey to the same forces that have caused it to decline all over the United States.

The Fuller Company did not cease its manufacturing operations on Front Street until 2004; by that time, it had been absorbed by the Danish giant in its industry, F.L. Smidth, which still retains some small operations on Front Street.

As has happened in most small, formerly industrial towns across the country, the businesses that remain are those that provide necessary services (home heating and cooling, car repair, personal services, and the like) rather than produce durable goods. The only heavy manufacturing in the boroughs is done by Phoenix Forging, which remains as the last direct link with the boroughs' industrial past.

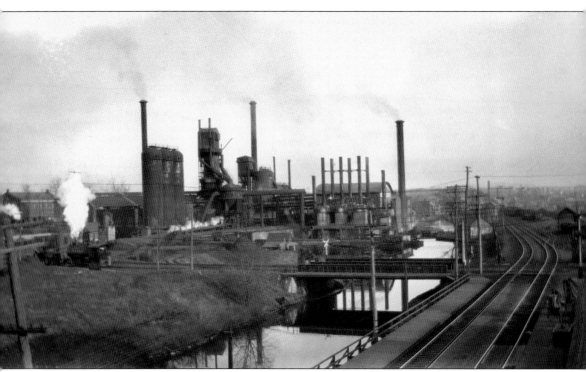

This striking image of the Crane Iron Works was taken from the Pine Street Bridge around 1920. Here is Catasauqua's 19th-century history in one place. David Thomas came from Wales to make iron with the anthracite that was carried down the Lehigh Coal and Navigation Company's canal. The reason his iron furnace was built here was that the canal's waterpower as it approached Lock 36 (seen center right, between the tall smokestack and the wooden building) was strong enough to drive the furnace's blowing engines. The canal was still carrying coal when this picture was taken, though trains had long since made most canals obsolete. The Central Railroad of New Jersey's tracks are on the right; the platform and the edge of the roof of its freight station are visible in the lower-right corner. The Crane's locomotive (also seen on page 91) steams down the tracks of the Lehigh New England Railroad, which came into Catasauqua through the tunnel, crossed Front Street and the ironworks, and crossed the Lehigh River on the trestle. The ironworks may still have been active at this time, but its days were numbered. (Historic Catasauqua Preservation Association.)

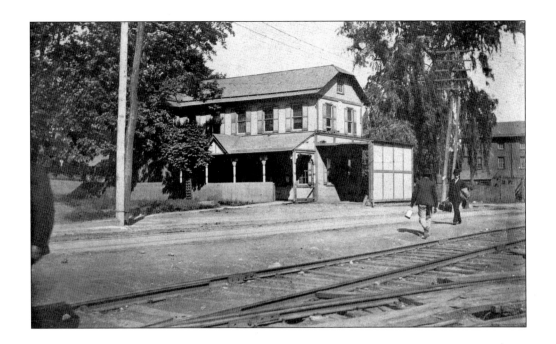

The building above, which still stands on Front Street, was one of the earliest constructed by the Lehigh Crane Company. By the time these photographs were taken around 1910, the company's laboratories were housed here. The four men below worked there, but only Ed Lynch (right) can be definitely identified. Of the others, two may be Milton and George Knauss. (Both, Catasauqua Public Library.)

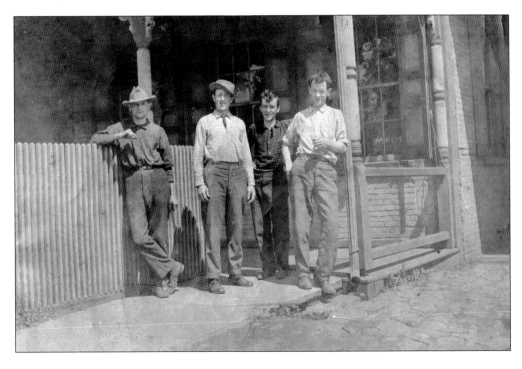

Pennsylvania's first thermometer manufacturer was Lehigh Thermometer Company, begun in 1910 by the Hillenbrand brothers. They constructed the building at 450 Chapel Street in 1916, and the business continued at that site until the 1960s. (Catasauqua Public Library.)

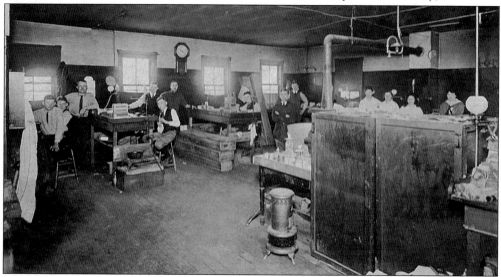

Keys Brothers and Company, manufacturer of medical thermometers, was incorporated in Catasauqua on March 1, 1911. Its facility, where this photograph was taken, was on the second floor of 115–117 Bridge Street. The owners were John and Bernard Keys and Henry Fries. When Bernard Keyes died in the flu epidemic in 1919, his brother bought out Fries and continued the business, but when it closed is not known. (Catasauqua Public Library.)

In this photograph, taken in the 1960s, two members of the Fuller Company's research department work on the problem of air circulation in cement storage silos. (F.L. Smidth Company.)

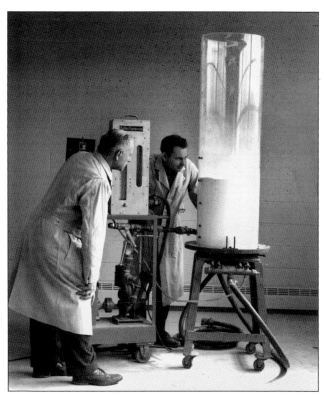

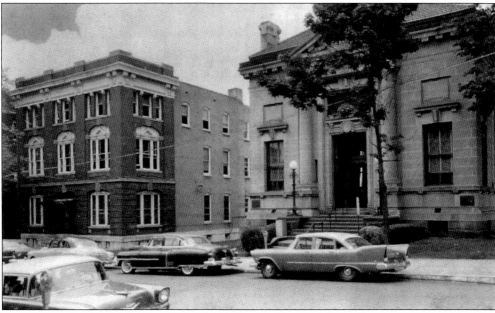

James W. Fuller III, known as "Colonel" Fuller, incorporated the Fuller Company in 1926 and purchased the former headquarters of the defunct Empire Steel and Iron Company (which had operated the Crane Iron Works) from Leonard Peckitt. That building, seen on the left in this photograph from the 1950s, was the first of several buildings in Catasauqua that housed company offices. The building is now My Home personal care facility. (Catasauqua Public Library.)

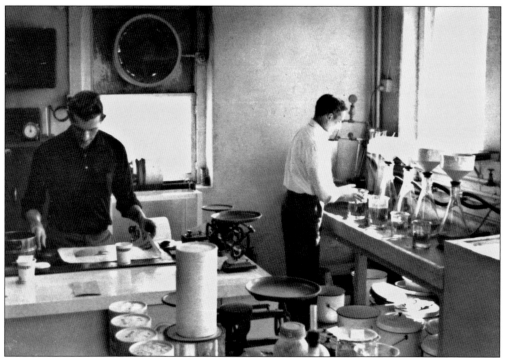

In the mid-1930s, the Fuller Company purchased 10 acres of the former Crane site and began producing its pumps, crushers, conveyers, and other equipment for the cement industry there. By the 1950s, it was the world's leading manufacturer of pneumatic conveying equipment. In the photograph above, from the 1960s, technicians work at the wet bench in the minerals separation laboratory, while the image below shows a testing facility for the pollution control devices that began to be used at that time. (Both, F.L. Smidth Company.)

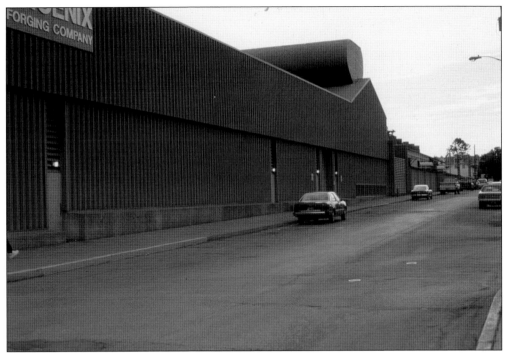

Phoenix Forging Company is now both boroughs' last link to their industrial past. As the demand for horseshoes plummeted after World War I, Phoenix Horse Shoe Company of Poughkeepsie, New York, bought the Bryden Horse Shoe Works in 1928. The company consolidated all its forging operations in Catasauqua. Several changes of ownership followed; since the 1980s, the plant has operated as part of the Phoenix Forge Group.

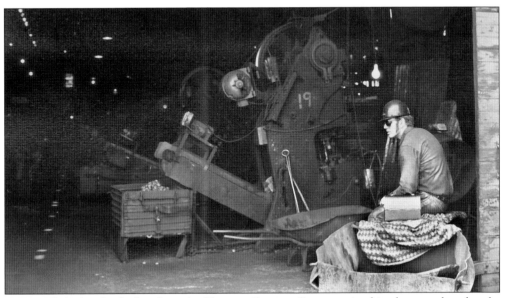

Dennis Hicks breaks for lunch at the Phoenix Forging Company in this photograph, taken by Jack Molchan some time in the 1970s. More pictures of Bryden Horse Shoe and Phoenix Forging are found on pages 104–109. (Larry Tait.)

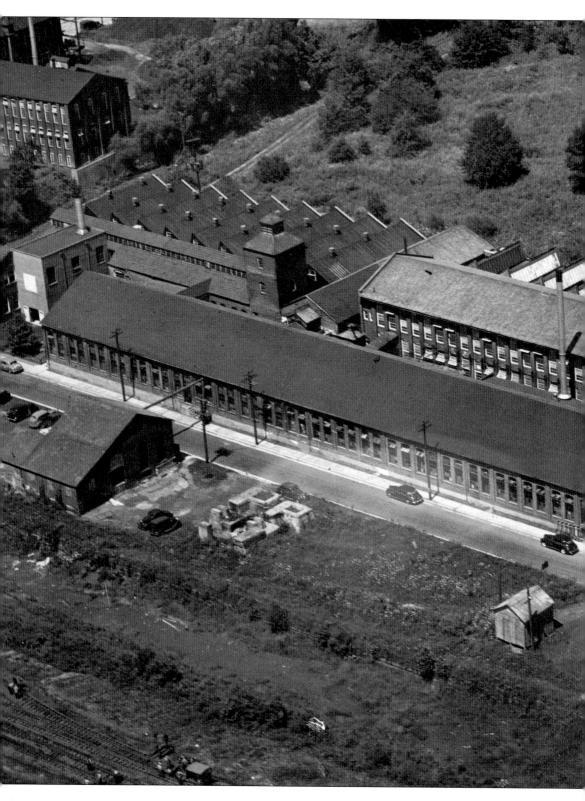

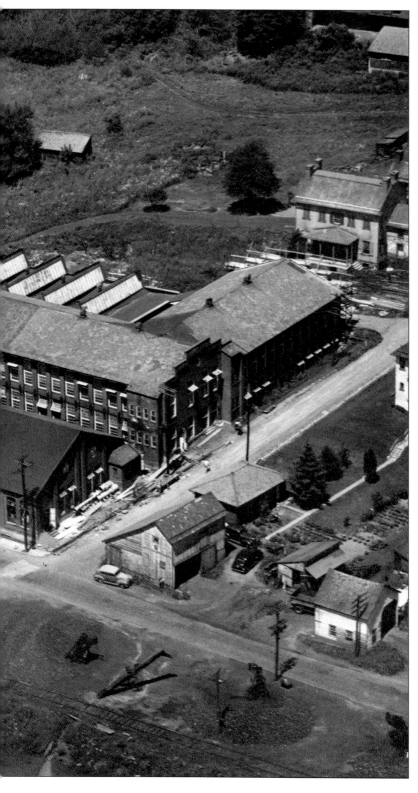

The silk mill that stood on the Canal Road was originally the Wahnetah Silk Mill, which operated from 1890 until the late 1920s. Later, it housed Cands Fabrics, another silk manufacturer, in the rear of the complex until 1970 and Catasauqua Silk Company in the front. These silk mills, along with the Dery Mill (later Fairtex) and General Ribbon (located in the former Unicorn Silk Mill on upper Front Street) provided employment for hundreds of the women in the boroughs. This photograph may have been taken after the 1942 flood, which inundated the canal, the railroad tracks (note the repair crews), and the front of the building. The unrestored Taylor House is in the upper right.

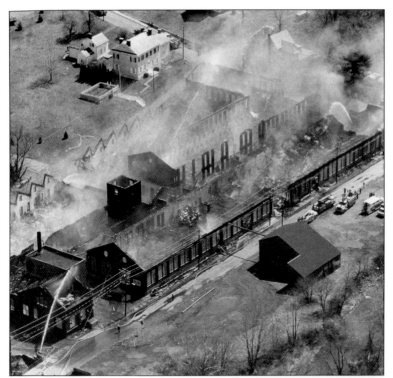

On the night of April 13, 1982, the former mill, which had housed the Jackson-Allen Furniture Company since 1971, burned in a spectacular fire that continued to smolder for several days. The fire departments' heroic work saved the Taylor House, which was only a few yards away from the conflagration. The next night, an equally large fire destroyed the Wint Lumber Yard for the final time. (Catasauqua Public Library.)

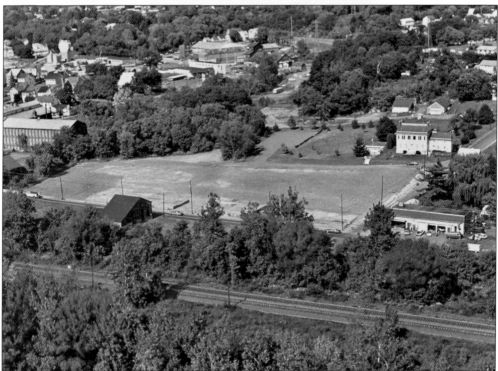

The site of the mill was acquired by Lehigh County Historical Society, then the owner of the Taylor House, and developed as the park that exists there at present. (Catasauqua Public Library.)

This is the former Dery Silk Mill as it appeared about 1950, when it housed Fairtex Mills. (Catasauqua Public Library.)

In the early 1980s, CitiHouse, an Allentown firm that rehabilitated old houses and industrial buildings, acquired the now vacant mill and renovated it into apartments while preserving the architectural features of the building. The former powerhouse now provides living quarters for the manager of the complex.

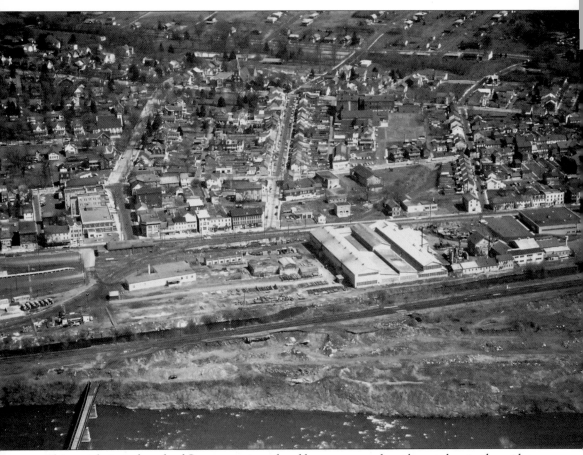

This aerial view of much of Catasauqua is undated but appears to have been taken in the mid- to late 1960s. Clues of the date include the presence of the Fuller Company building, which is now the borough hall on Bridge Street; the large, barn-like structure that stood at Second and Peach Streets, where the telephone exchange building is now located; and the absence of train tracks to the tunnel, which appears to be partially blocked. (Catasauqua Public Library.)

Two

The Death, Rebirth, and Death of the Canal

Well into the 20th century, canal boats laden with anthracite coal still passed through Catasauqua and stopped to unload coal at George Deily's and Dan Milson's coal yards near Race Street. But the boats became fewer as the 1930s progressed, and the canal stopped being a viable part of its business for the Lehigh Coal and Navigation Company. The flood of May 22–23, 1942, which is pictured on the following pages, destroyed the last vestiges of commercial activity on the canal. Even worse flooding caused by Hurricane Diane in August 1955 did more damage.

There were two structures that were critical to keeping the canal alive on its course through the boroughs. The first was the Hokendauqua Dam, a "wing dam" that guided water (and boats, in the day) through Guard Lock 6 (the ruins of which can still be found under the Hokendauqua Bridge) and into the canal. Miraculously, the dam and locks survived every flood. The second critical structure was Lock 36, which kept the water level steady up to the guard lock and fed water down to the next lock, near the site of the current Catasauqua Lake park.

After Hurricane Diane, a small but dedicated group cleaned up Lock 36 and put the lock gates, which had been dropped to the bottom of the canal bed, back into position. Though the lock would not open and close, this was enough to keep a good level of water in the canal. The canal became a heavily used recreation area for fishing, canoeing, swimming, and ice skating from the late 1950s until the end of the 1970s.

Then disaster struck again, this time in the form of a dynamited ice dam upstream that hurtled down the Lehigh during the winter of 1980 and broke every dam in its path. With the wing dam gone, the level of the Lehigh River was too low to reach the guard locks. Since then, the canal bed is mostly dry, except when heavy rains fill it back up.

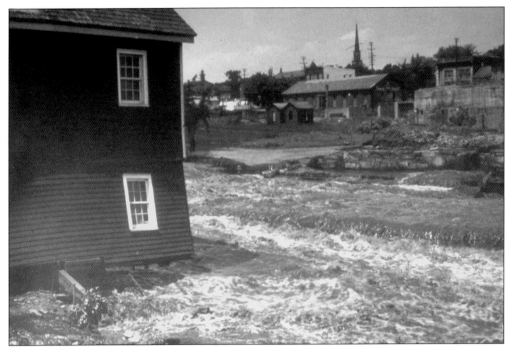

Lock 36 appears in the immediate aftermath of the flood of May 22–23, 1942. In the photograph above, the lock tender's house has been partially swept off its foundation. In both photographs, water and debris fill the canal bed and its banks. (Both, Historic Catasauqua Preservation Association.)

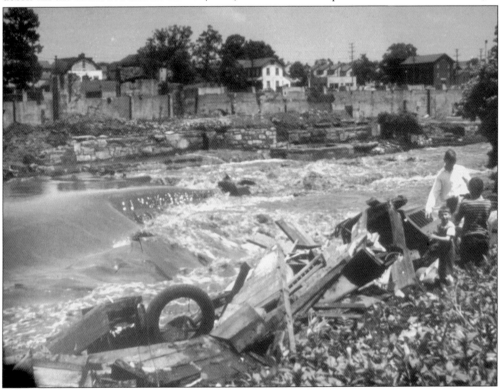

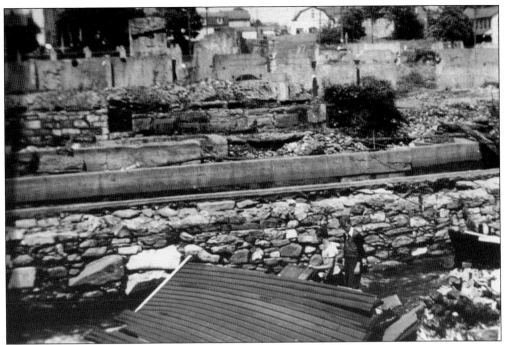

This photograph shows the devastation of the lock. Even if there had been any strong economic reasons for rebuilding the canal, they were outweighed by the demands of World War II. (Historic Catasauqua Preservation Association.)

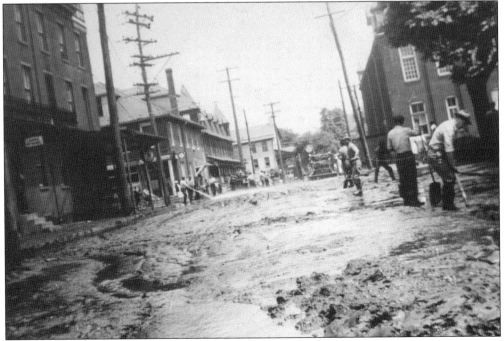

Men with fire hoses attempt to flush the mud and debris off Race Street between Front and Lehigh Streets. Floodwaters reached nearly to Front Street in this neighborhood. (Historic Catasauqua Preservation Association.)

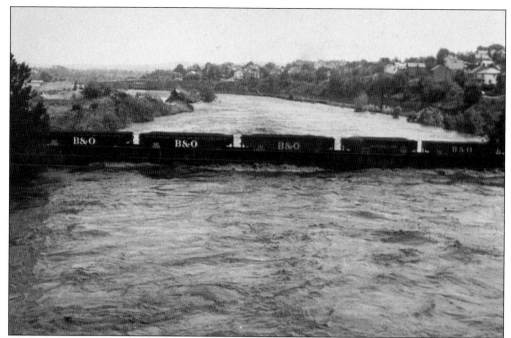

The flood of 1942 was sudden and unexpected. The flooding caused by Hurricane Diane in 1955 was a bit more predictable, which gave the railroads time to stabilize their trestles with loaded coal cars. But this picture, taken from the Pine Street Bridge, shows the incredible rise in the Lehigh River during this flood. (Historic Catasauqua Preservation Association.)

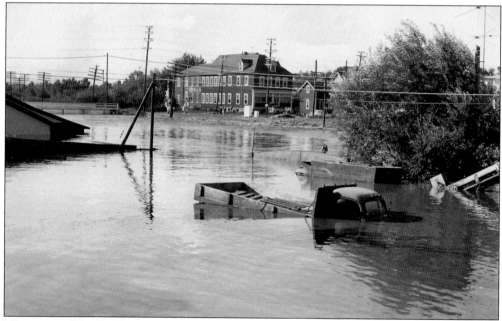

The extent of the flooding from Hurricane Diane is visible in this photograph of the Tassie Coal Yard, now part of Historic Catasauqua Preservation Association's property on Race Street. The depth of the water can be gauged by looking at the roof of the mule barn in the left of the picture. The Smith Candy Company is in the background. (Historic Catasauqua Preservation Association.)

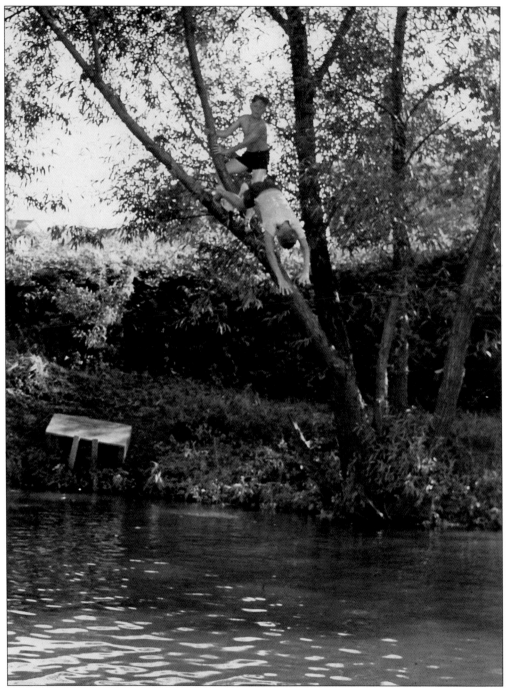

This was the scene only three years later, when the canal restoration made it deep enough to dive into from an overhanging tree. One of these boys may be "Young Tony" Imhof, as the picture was taken by his father, Tony Imhof Jr., near their home on Union Street.

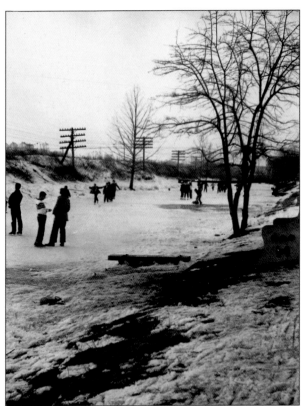

The same stretch of the canal, at the end of Union Street, is wearing its winter coat of ice in 1958. Ice skating on the canal was a popular winter pastime. It was possible to skate from Rohn's Springs, near the present Catasauqua Lake, to the Hokendauqua Dam. Residents who remember this say it is much more fun than going round and round an ice rink.

Tony Imhof Sr. spends some serene summer hours on a bench by the canal with his neighbors. His son Tony Imhof Jr. took this picture in 1958.

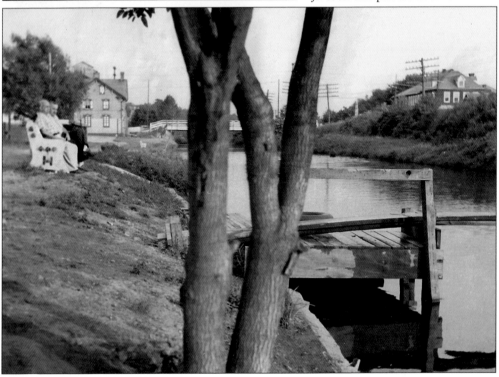

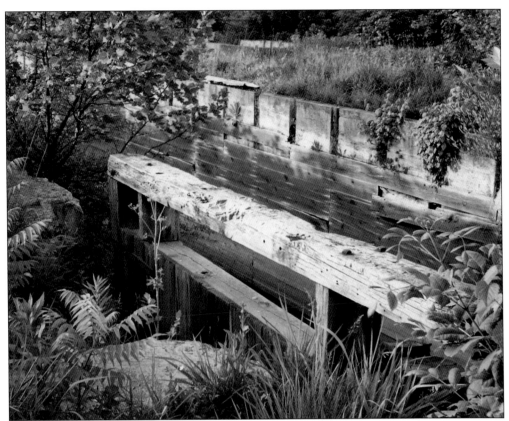

Tony Imhof took the picture above of Lock 36 in 1954, when planning for the canal restoration was in progress. Though overgrown, the gates and walls of the lock appear to be intact. The image below was taken in June 1971 and shows the same gate from the opposite bank of the canal. The gate has since fallen from the wall and largely disintegrated.

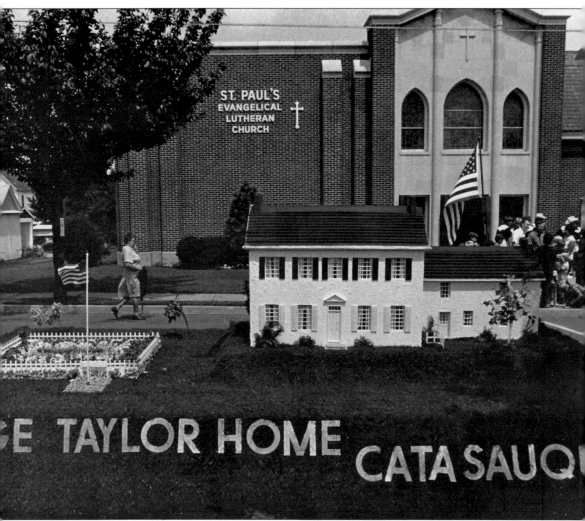

The Taylor House float moves down Howertown Road during the Bicentennial Parade in 1976. Catasauqua had a special reason to celebrate the 200th anniversary of the Declaration of Independence, because signer George Taylor built the beautiful Georgian-style house on Canal Road in 1768 and farmed the land surrounding it until his death in 1781. Of all the Pennsylvania signers, only Taylor's houses (another is in Easton) are still standing. (Catasauqua Public Library.)

Three

THE BICENTENNIAL AND OTHER CELEBRATIONS

Catasauqua and North Catasauqua's observance of the US bicentennial in 1976 was the biggest celebration in the boroughs since Old Home Week in 1914. Planning began three years before the event. Along with the historic and patriotic aspects of the occasion, the planners decided to incorporate events and activities that would let residents of all ages and interests actively participate in the celebration. So games and athletic competitions such as basketball, volleyball, baseball, and a swim race were held at both playgrounds and the swimming pool, and the Catasauqua Band and the German Band played concerts. Various churches and organizations were invited to sell food and drinks, and local craftspeople displayed their work. A large crowd packed Alumni Field twice: first for the opening program on July 6, and later, for a huge fireworks display.

The spirit of 1976 was so exhilarating that the organizers decided to keep on observing the Fourth of July with community celebrations. The J4 organization put together two-day events—one day in North Catasauqua and the other in Catasauqua—for several subsequent years. Some of these also marked other special events, especially the dedication of the new North Catasauqua Fire Station in 1980.

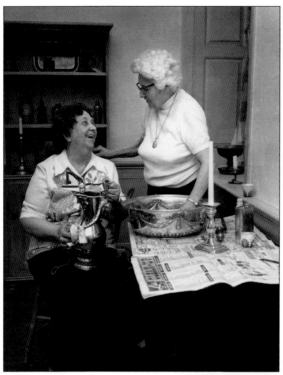

Ethel Strode (left) and Lillian Young polish the silver as they help prepare the George Taylor House for the bicentennial ceremonies. (Catasauqua Public Library.)

Members of the Northamptontowne Militia, a group of Revolutionary War reenactors, march across the Taylor House lawn to the bicentennial closing ceremony. The former Cands Fabrics silk mill is in the background. (Catasauqua Public Library.)

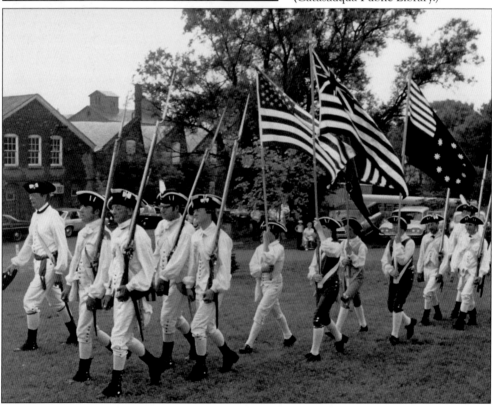

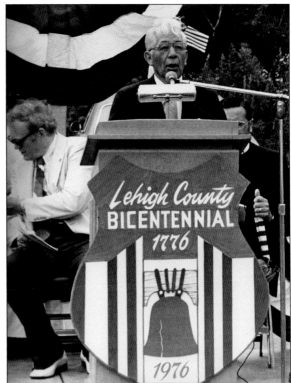

At right, Catasauqua mayor Leonard Witt Sr. speaks at the bicentennial closing ceremonies at the Taylor House on July 11, 1976. Other speakers pose on the platform, including, from left to right below, Lehigh County Historical Society president Abram Samuels; celebration organizer Bill Albert; Leonard Witt Sr.; A. Newton Bugbee Jr.; Rev. Joseph Falzone, pastor of St. Stephen's Episcopal Church; Rev. Robert Dressler, pastor of St. Lawrence Roman Catholic Church; and Rev. Philip Miller, pastor of St. Paul's Lutheran Church. (Both, Catasauqua Public Library.)

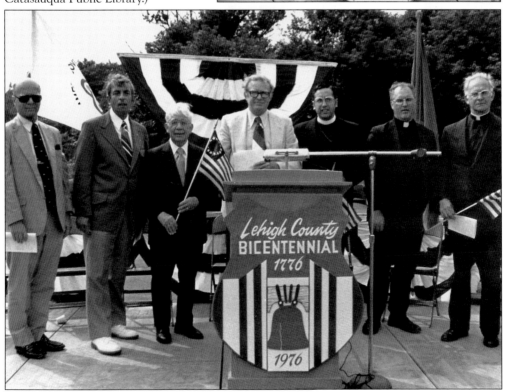

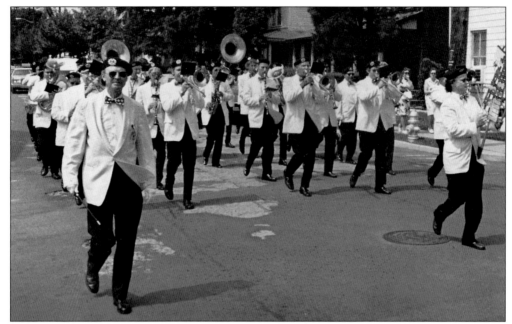

The Catasauqua Band, led by band director Vincent Suppan (front left), marches down Howertown Road in the parade on July 11, 1976, for the closing of the bicentennial celebration. Members of the American Legion Post 215 marched ahead of the band, led by the color guard. (Both, Catasauqua Public Library.)

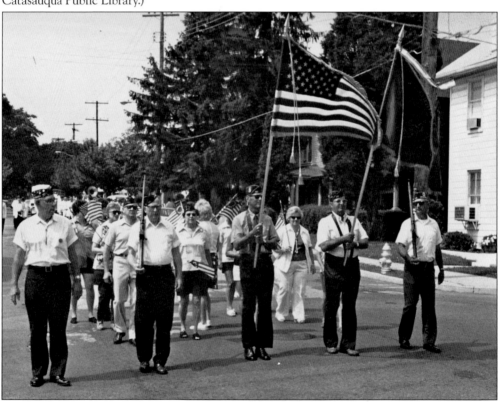

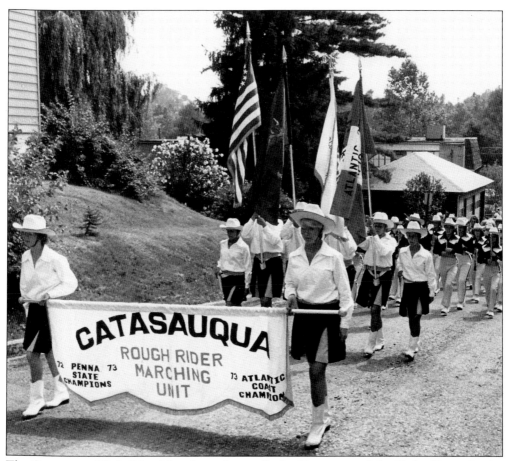

The Catasauqua High School band marches up Poplar Street toward the Taylor House for the bicentennial ceremonies, followed (below) by some of the speakers. From left to right are A. Newton Bugbee Jr., Monica Bugbee, Nancy Albert, Bill Albert, and Leonard Witt Sr. (Both, Catasauqua Public Library.)

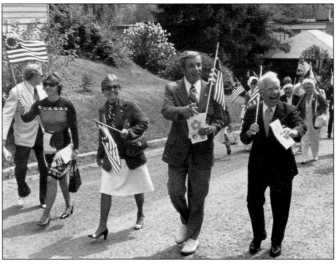

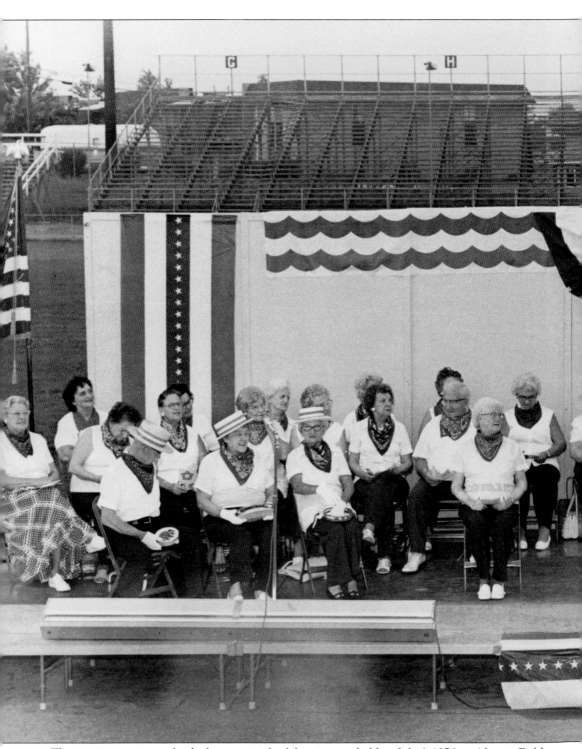

The opening ceremony for the bicentennial celebration was held on July 6, 1976, at Alumni Field. (The actual Bicentennial Week began on July 4, though some events were held earlier.) The group on stage in this photograph was of senior citizens who put on a minstrel show as part of

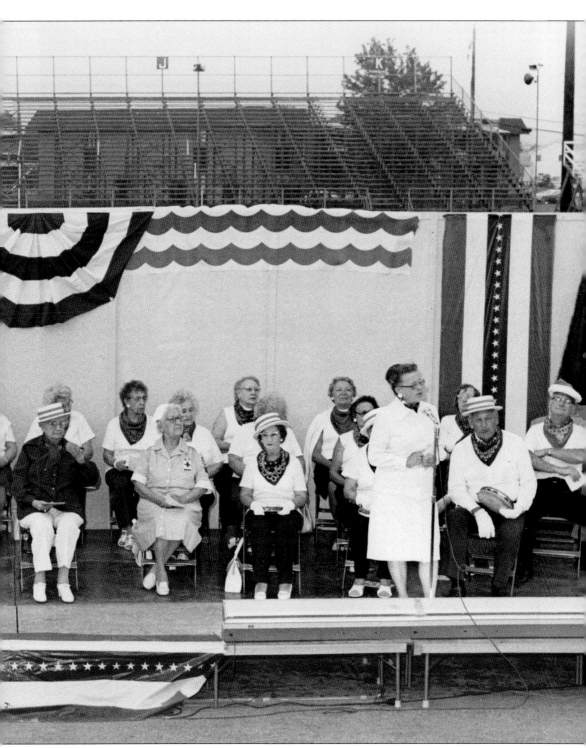

those festivities. Blodwyn "Bobby" Powell (standing, right) introduces the act. (Both, Catasauqua Public Library.)

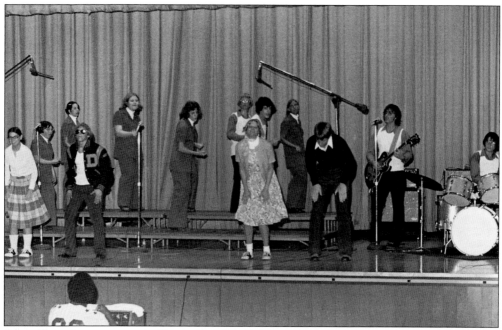

Borough residents put on an oldies rock-and-roll show as part of the bicentennial celebrations at the North Catasauqua playgrounds. (Catasauqua Public Library.)

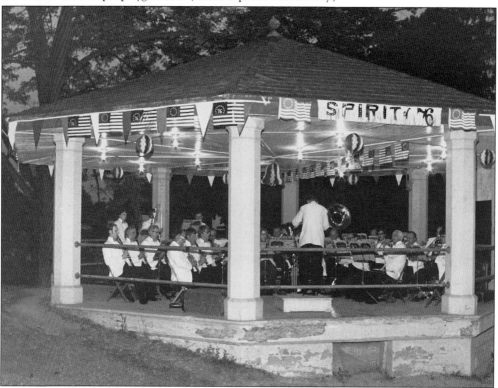

At the old bandstand at the Catasauqua playgrounds, traditional patriotic music made up the program presented by the Catasauqua Band. (Catasauqua Public Library.)

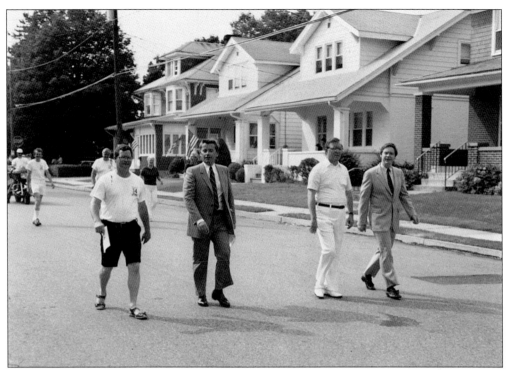

The success of the bicentennial celebration spurred the organizers to plan regular community Fourth of July celebrations. The 1983 celebration featured a bicycle race through the streets of both boroughs. That year, the opening ceremonies were held in the North Catasauqua playgrounds, and organizers and local dignitaries led the parade through the streets of the borough. Appearing in the photograph above are, from left to right, North Catasauqua mayor Bill McGinley, Guy Kratzer, John McHugh, and then–state representative Paul McHale. In the picture below are, from left to right, Joe Tognoli, Jim Scheetz, Nancy Albert, and Bill Albert. (Both, Catasauqua Public Library.)

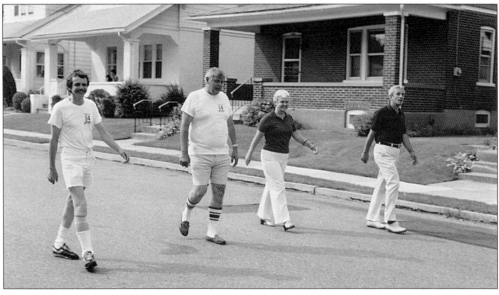

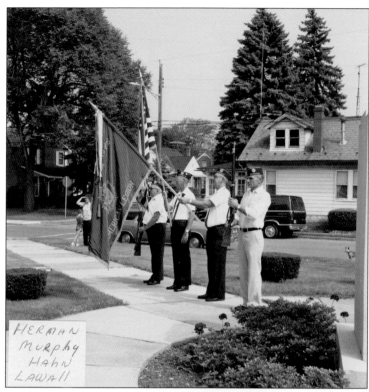

HERMAN
MURPHY
HAHN
LAWALL

The American Legion color guard salutes the raising of the American flag at the opening ceremonies of the 1983 J4 celebration in the photograph at left, while the Northamptontowne Militia fires a cannon salute below. (Both, Catasauqua Public Library.)

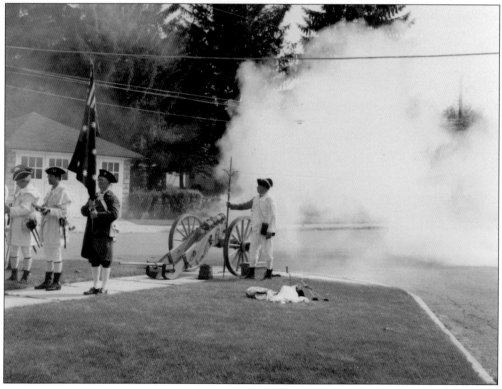

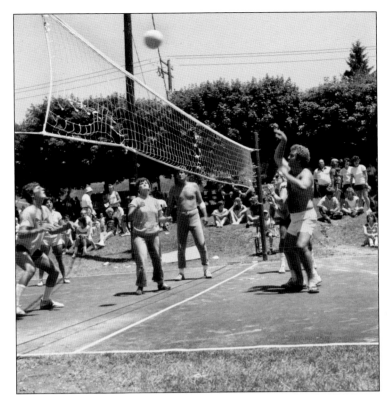

In a tradition started by the Bicentennial, the J4 celebrations included basketball and volleyball tournaments for any and all residents who wanted to play. (Both, Catasauqua Public Library.)

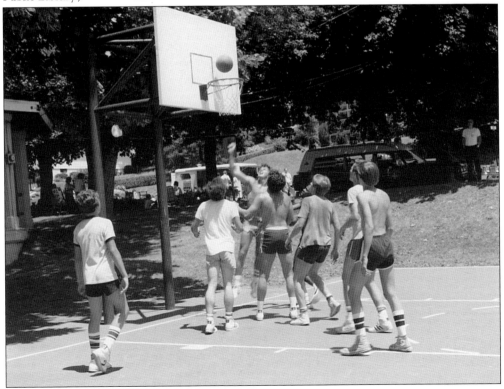

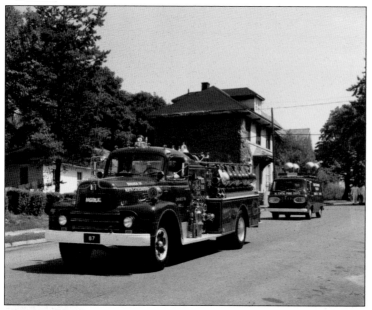

The highlight of the 1980 J4 celebration was the dedication of the new firehouse for North Catasauqua's Charotin Hose Company. The Charotin's trucks and firefighters paraded down Chapel Street from their former home at Sixth and Arch Streets to the new station on Chapel Street. (Both, Catasauqua Public Library.)

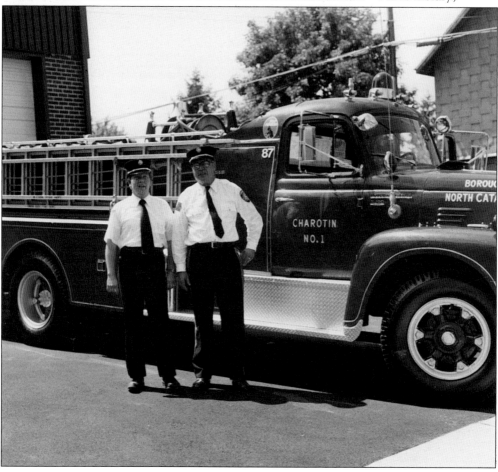

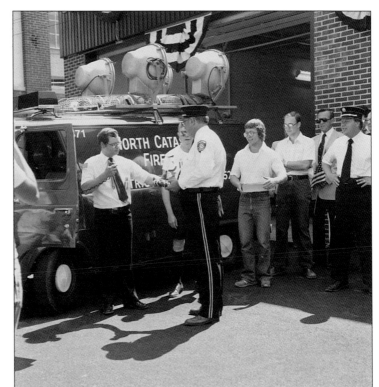

At right, at the new station, fire chief Bill McGinley (left) uses the floodlight van's speakers to address former fire chief John Reichl and the gathering. In the photograph below, the fire fighters push Charotin No. 1 into its new home. (Both, Catasauqua Public Library.)

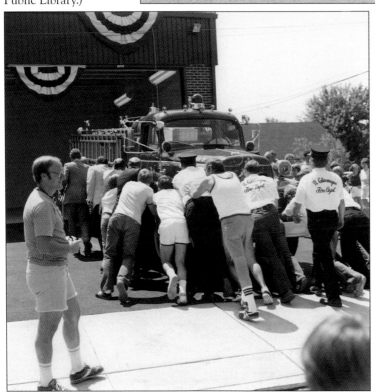

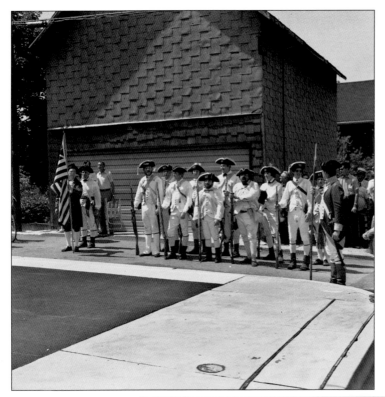

After standing watch at the dedication of the new fire station (shown at left), the Northamptontowne Militia marched to their encampment site in the Catasauqua playgrounds. The next morning, they enjoyed a hearty Colonial-style breakfast prepared over open fires by their camp followers. (Both, Catasauqua Public Library.)

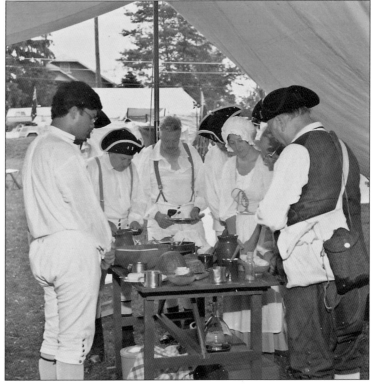

At right, the 1980 J4 celebration included a flower show. Under the large pavilion at the Catasauqua playgrounds, Edith Bartholomew, Verdi Hazlinsky, and Jan Helker admire the arrangements. Members of the Suburban North YMCA (below) sell food from their stand on St. John Street to raise money for the organization. (Both, Catasauqua Public Library.)

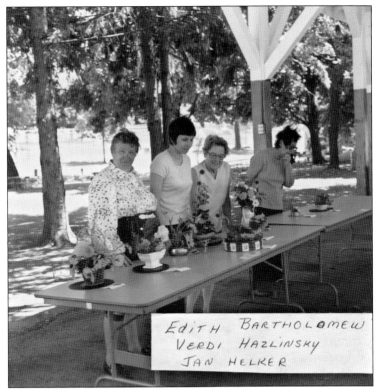

Edith Bartholomew
Verdi Hazlinsky
Jan Helker

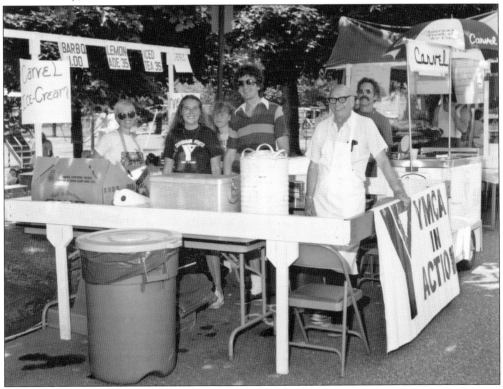

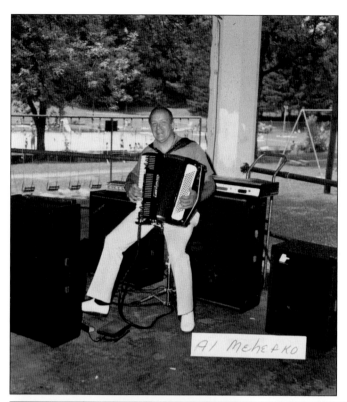

Al Mahefko, a frequent performer at festivals in both boroughs, entertains with his versatile accordion in the bandstand during the 1983 J4 celebration (right). Grace and Ernie Hilfiker (below) were always on hand at community festivals, like the 1983 J4, to show their handicrafts and greet their many friends. (Both, Catasauqua Public Library.)

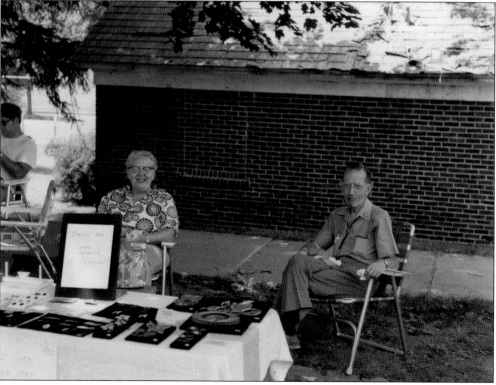

Four

SCHOOLS ARE THE TIES THAT STILL BIND

In Catasauqua and North Catasauqua, many people see their former school classmates frequently—on the street, in the post office, at meetings, in church, and at town events. This does not seem unusual, until visitors and newer residents point out that it's not a common experience for many Americans today. But here, it is one of the strongest bonds in the community.

If anything, school became an even stronger link in the past 40 years. That's because in the early 1970s, the various elementary schools were consolidated at Scheckler Elementary, bringing all the district's youngest students under one roof. At the same time, financial pressures closed both Catholic elementary schools, and most of their pupils moved into the public schools.

Thus, from that time until recent years, when charter schools and the enhanced curriculum at Lehigh Career and Technical Institute began to draw some students away, many residents moved through the three schools—elementary, middle, and high school—from kindergarten through high school graduation with the same classmates. The friendships and relationships forged in those school years continue to define life, work, social life, and even love decades later.

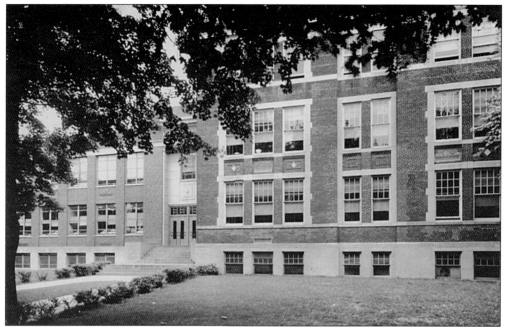

Catasauqua High School—the Lincoln School—is shown above as it looked in the late 1950s. The original high school building, constructed in 1904, is not visible in this picture, but it still stands at the northern end of this site, along Hickory Street. The section of the building seen here replaced the original Lincoln School, which burned in 1940. (Catasauqua Public Library.)

The Lincoln Gym, constructed in 1954, replaced the gym building that had stood alongside the main school on Howertown Road. That building was over the tunnel and was condemned when large cracks appeared in the floor, possibly from the shaking from trains passing below. Lehigh Valley Christian High School has occupied the building since 2009. (Historic Catasauqua Preservation Association.)

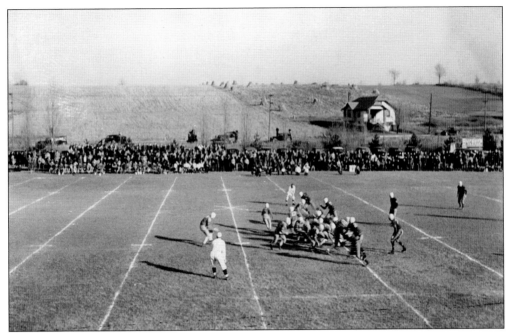

The Catasauqua High School Rough Riders play an unidentified opponent in a game on Thomas Field some time in the 1930s. Note the harvested fields right down to St. John Street in the background. The house in the picture still stands at 621 St. John Street. (Historic Catasauqua Preservation Association.)

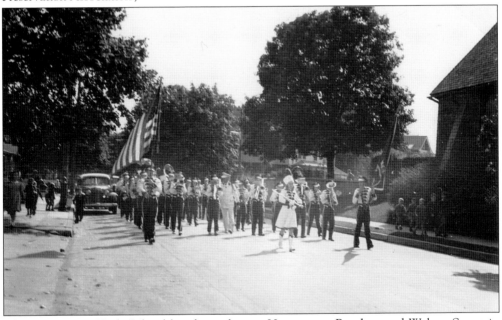

The Catasauqua High School band marches up Howertown Road toward Walnut Street in this undated photograph. The musicians appear to be playing, but the dearth of spectators and the presence of a car at the curb suggests they may be marching to the starting point of a parade. Their band uniforms suggest a date in the post–World War II years. (Historic Catasauqua Preservation Association.)

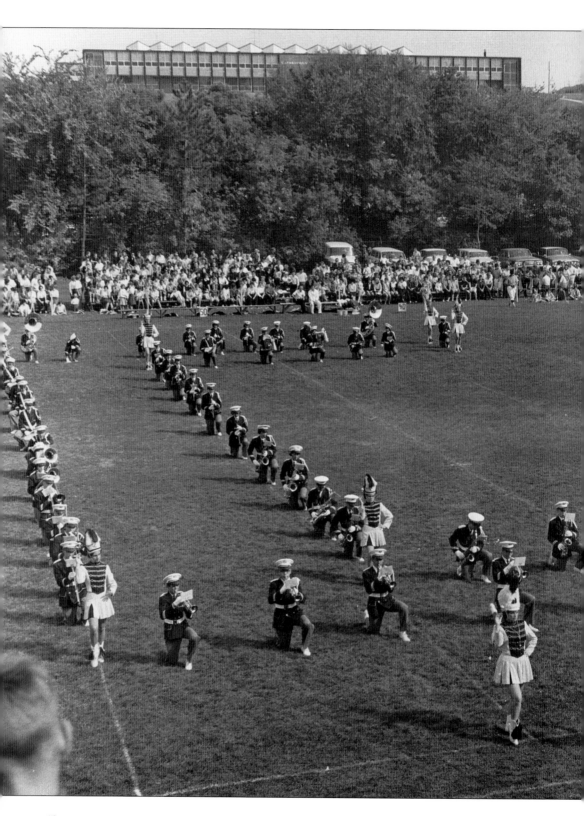

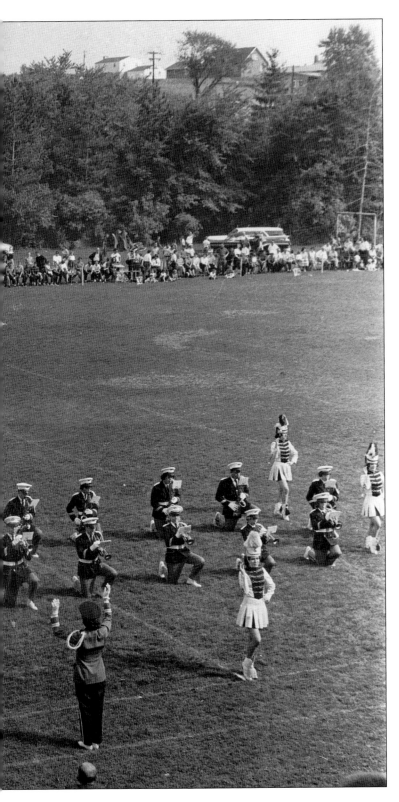

The high school band performs on Thomas Field in this undated photograph, which judging by the cars and the presence of the then-new high school in the background was taken some time in the mid-1960s. The majorettes' uniforms are remarkably similar to the one in the previous picture, but the band had switched to the military-style jacket and tie uniform in the late 1950s. (Both, Historic Catasauqua Preservation Association.)

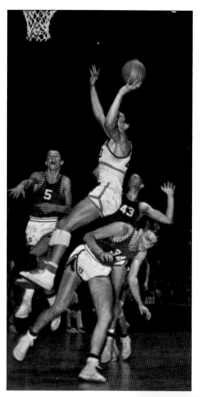

Catasauqua High School has boasted some excellent basketball players. But none was as great a player as Larry Miller, who graduated in 1964. In a state championship playoff game that year, Miller scored 46 of Catty's 66 points to defeat Steelton High. Miller was named to the *Parade* magazine All-American high school team in the same year as Lew Alcindor (later Kareem Abdul-Jabbar) and Wes Unseld. Miller went on to play at the University of North Carolina under the legendary coach Dean Smith and was the Atlantic Coast Conference's Men's Basketball Player of the Year in 1966 and 1967. (Both, Catasauqua High School.)

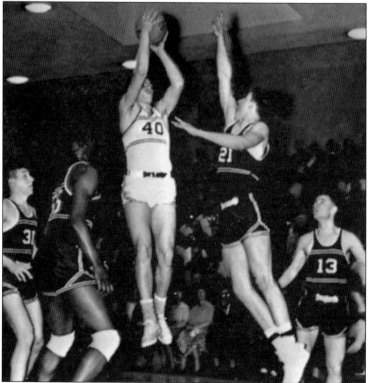

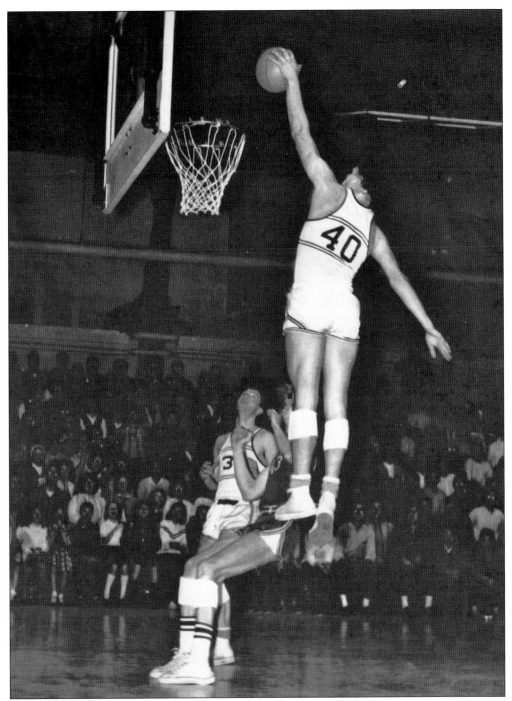

A six-foot-four-inch forward, Larry Miller played professional basketball from 1968 to 1975 in the American Basketball Association (ABA) as a member of teams including the Carolina Cougars, the Los Angeles Stars, and the Utah Stars. He set the ABA record of 67 points scored in a single game on March 18, 1972. (Catasauqua Public Library.)

Senior Bruce Kohl cheers a score by the 1983 Colonial League champion Rough Riders. The Rough Riders' perfect season of 11 wins owed a lot to its defensive players, who allowed only 21 points all season. (Catasauqua High School.)

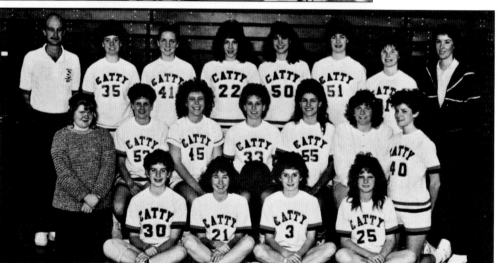

The 1988 Catasauqua High School girls' basketball team is the school's only squad ever to win a state championship. Their 28-win season, with only two losses, culminated in a 58-42 victory over Bishop McCort High School on March 25, 1988. Pictured above are, from left to right, (first row) Lisa Keeler, Amy Miller, Jen Green, and Kim DeLucia; (second row) manager Barbara Keglovitz, Jamie Scheetz, Stacey Paukoviitz, Janice Cesanek, Chris Snyder, manager Sue Lynch, and Lori Deutsch; (third row) assistant coach Tom DeLucia, Molly Lauback, Jenny Greener, Lisa Dieter, Stephanie Sheckler, Missy Foster, Heidi Fehnel, and coach Patti Heffner. (Catasauqua High School.)

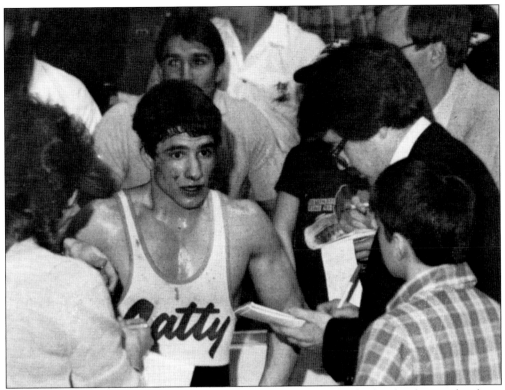

Matt Gerhard, class of 1984, was an all-round athlete during his high school years, but he is most remembered for dominating his weight class statewide in wrestling. Gerhard won the state championship in the 119-pound class during each of his high school years, a feat achieved at that time by only four other Pennsylvania wrestlers. (Catasauqua High School.)

From left to right, track team members Heather Howlett, Tammi Haines, Kim Kemmerer, Becky Gemmel, and Jon Linton were all champions at the 1990 Colonial League track meet. Jon Linton was the third CHS graduate to go on to a professional sports career, playing with the Buffalo Bills from 1998 to 2000. (Historic Catasauqua Preservation Association.)

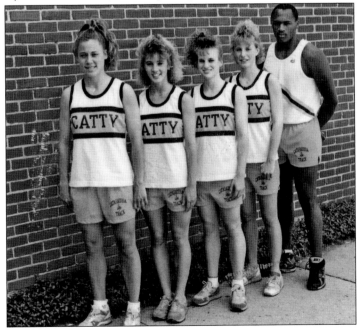

Catasauqua's youngest students finally were gathered all together in one school when Francis H. Sheckler Elementary School opened in 1972. Dedicated on February 11, 1973, the 96,000-square-foot building had a capacity for over 1,200 students as well as office space for the school district administration. The school's unique design offers large windows and an enclosed courtyard with trees and a small pond. (Both, Historic Catasauqua Preservation Association.)

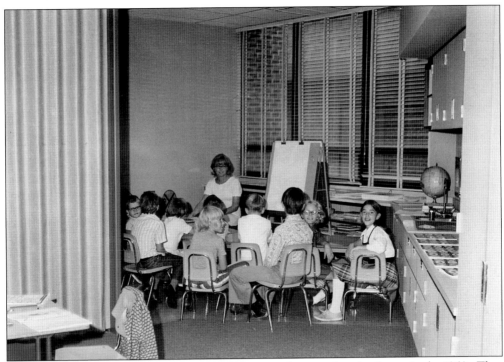

Sheckler's layout and design reflects shifts in educational approaches that began in the 1960s. Thus some smaller rooms for specialized classes, such as reading support, were incorporated in the floor plan (above), while a large tiered room with audiovisual equipment was created for bigger classes, meetings, or special events. In the picture of the large group room below, assistant principal Loren Keim and teachers Joann Zarembo and Mary Schmidt introduce Sheckler students to their new learning environment. (Both, Historic Catasauqua Preservation Association.)

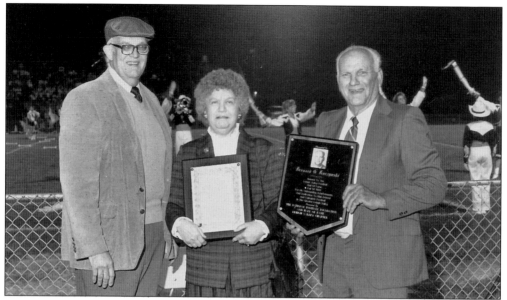

Catasauqua High School principal Frank Troxell honors Bert Kuczynski as he is inducted into the Lehigh Valley Chapter of the National Football Hall of Fame in September 1988. Kuczynski held both bachelor's and master's degrees from the University of Pennsylvania, where he was named to the 1942 All-American team. After graduating in 1943, he played for the Philadelphia Athletics and then moved immediately to the Detroit Lions, thus becoming the first person to play in both major professional leagues in one year. (Catasauqua Public Library.)

Bert Kuczynski joined the faculty of Catasauqua High School in 1948 as a social studies teacher and was the head football coach from 1948 to 1959, posting nine winning seasons. He also coached baseball for 11 seasons. Here, Kuczynski and his wife, Dotie, greet his former assistant coach Donald "Jake" Buzzard (center), his wife, and Will Strine (left) during a football game at Alumni Field. (Catasauqua Public Library.)

Five

FUN AND FROLIC IN THE GREAT OUTDOORS

Visitors to Catasauqua and North Catasauqua often remark that the public playgrounds and swimming pool are very large for such small towns. Twenty-first-century residents are lucky that those who came before them set aside these generous open spaces for recreation and a bit of retreat from what was once a booming (and rather sooty) industrial town. These venerable—and heavily used—green spaces have been the go-to, year-round gathering places in these communities for decades and are still where many people of all ages head for fun, fresh air, music, movies, and healthy exercise.

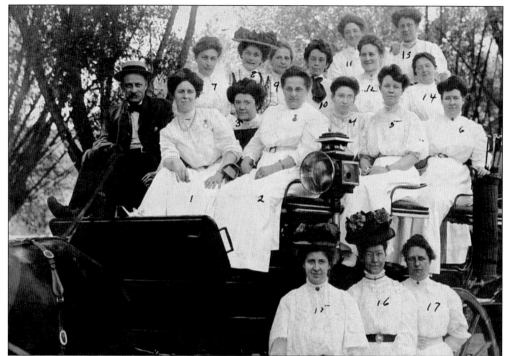

Minnie Milson Thomas, number 10 in the picture, was a fervent believer in the benefits of fresh air and healthy exercise, especially for people who worked long hours in factories, and most especially for children. She and her husband, William Thomas Jr., drove forward the Old Home Week committee's resolution to create a playground as a permanent memorial to the 1914 celebration. The former high school football field at Walnut and St. John Streets is named for them. (Catasauqua Public Library.)

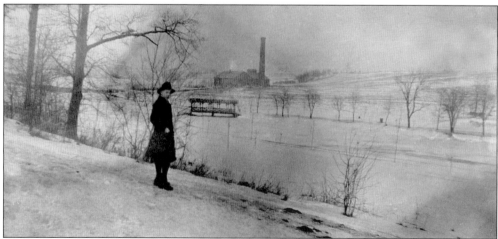

It is not known who is surveying the winter landscape of the playgrounds, or when the photograph was taken, but it must be after 1916. That year, William and Minnie Thomas had succeeded in persuading the borough, the school district, the landowners, and local residents to back the playgrounds project, and by Labor Day of that year, a usable public recreation space was in place along the Catasauqua Creek. The rustic bridge over the creek, also seen in the next photograph, and the borough water works are in the background. (Catasauqua Public Library.)

The girls in these two charming pictures are wearing costumes, but the event they were participating in is unknown. However, the playgrounds shows signs of fairly recent construction, so the occasion may have been the Welcome Home celebration for the returning service people from World War I, which was held in late August 1919. (Both, Catasauqua Public Library.)

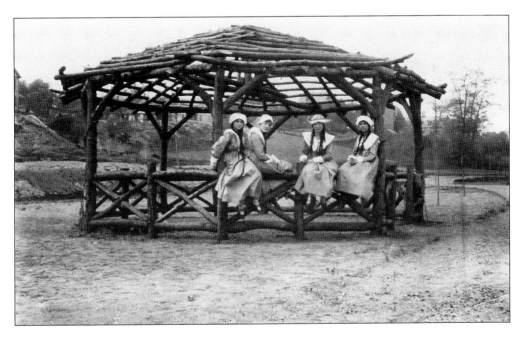

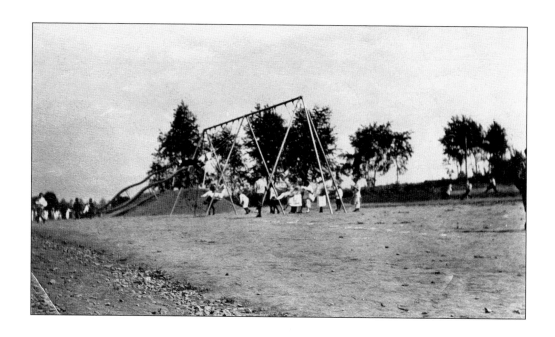

The frame for swings in the photograph above may be the one that is still in use in the St. John Street playgrounds today. The sliding boards on the hill in the background look like they provided a thrilling ride. The blur in the center of the photograph below suggests that this wooden contraption spun. The watching children may have been waiting for their turn to face-plant in the dust, but why there were adult spectators is unknown. (Both, Catasauqua Public Library.)

St. Paul's Lutheran Church in the background indicates that these people were gathered in the area that is now the swimming pool parking lot. The playgrounds were run by a nonprofit community group that had to continuously raise funds to maintain the park and programs. The picture below and those on the next two pages are from a festival that appears to have been held in the early 1920s. In this photograph, the men are ready to sell cold drinks. Their hats and coats are hung up in the back of the booth. (Both, Catasauqua Public Library.)

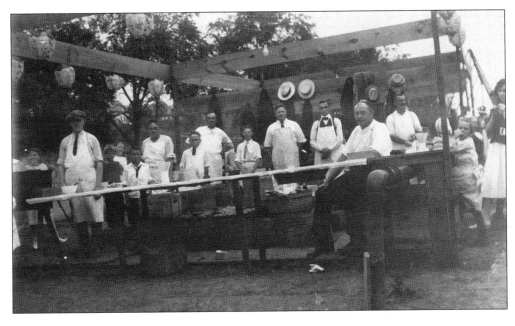

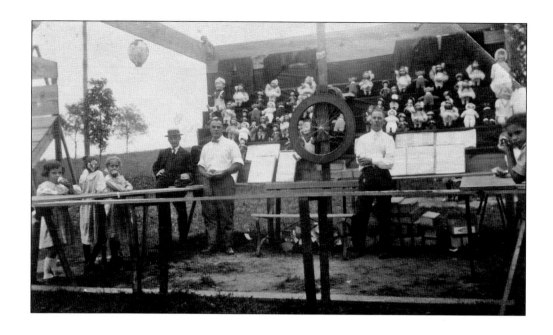

No doubt each of these little girls would have loved to win one of the dolls so temptingly displayed in the picture above. Meanwhile, the sign over the game of chance in the photograph below was at least honest. (Both, Catasauqua Public Library.)

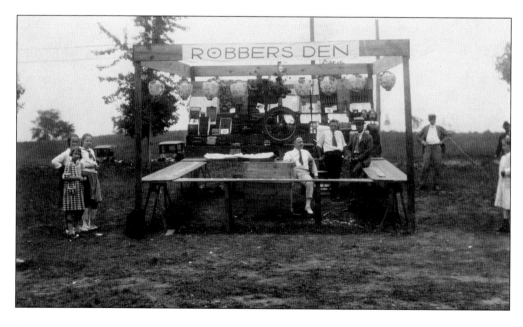

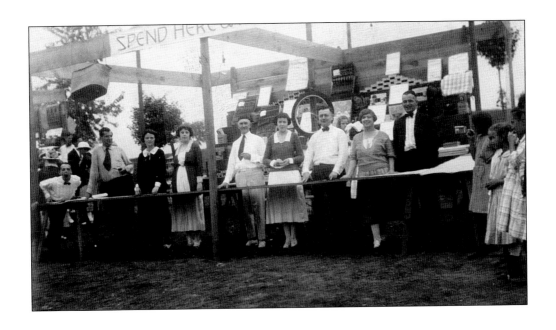

"Spend Here & Prosper" seems like a dubious claim for a game of chance, and it is not clear what one could win if one got a lucky spin of the wheel. (Both, Catasauqua Public Library.)

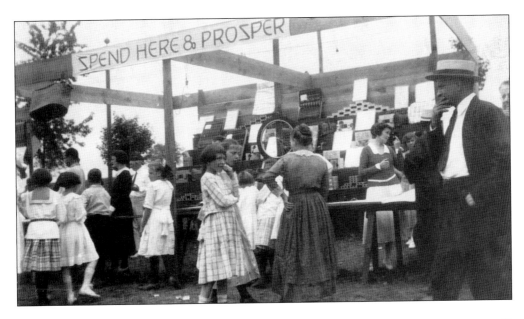

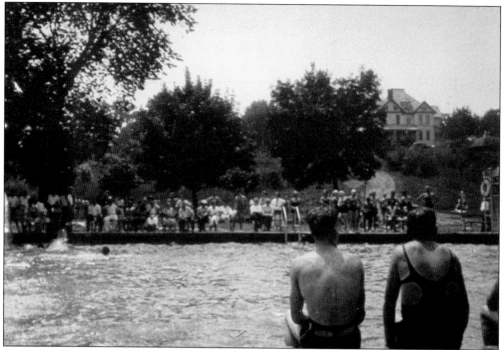

This rare photograph, possibly taken by Tony Imhof Sr., shows the Catty Pool during its first summer in 1935. The absence of fences and lifeguard chairs is noticeable. But the crowds of swimmers show how glad residents were to have the pool in place of the shallow, muddy swimming hole that had been there since 1917. (Historic Catasauqua Preservation Association.)

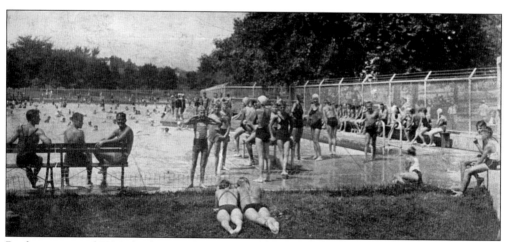

By the summer of 1936, the fence and elevated lifeguard stands were in place. The pool was built with money and labor provided by the federal Work Projects Administration (WPA), which put unemployed men to work during the Depression. The original pool was 220 feet long and 90 feet wide and held 588,000 gallons of water. (Catasauqua Public Library.)

The diving boards—the "divies" as they were called—appear as they looked after the pool renovation of the late 1960s. When this photograph was shot on July 4, 1980, there were still two low diving boards and the high dive. (Catasauqua Public Library.)

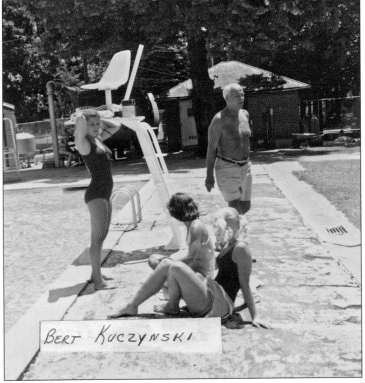

BERT KUCZYNSKI

Catty Pool manager Bert Kuczynski already sports his deep summer tan in this picture, taken on the same day. Then newly retired from teaching, he was the no-nonsense pool manager for most of the 1980s. (Catasauqua Public Library.)

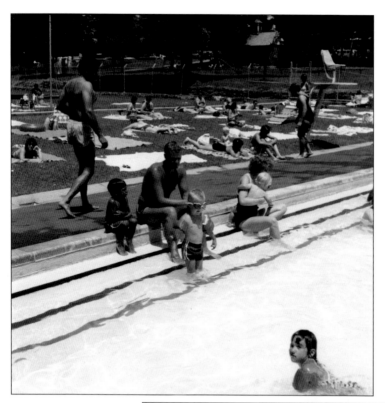

The sliding boards made parents and lifeguards alike nervous (below), but they were enormously popular with the children. The steps at the shallow end were always filled with watchful parents and adventurous toddlers. However, the current "natural" sloped shallow end of the pool is more popular with everyone. (Both, Catasauqua Public Library.)

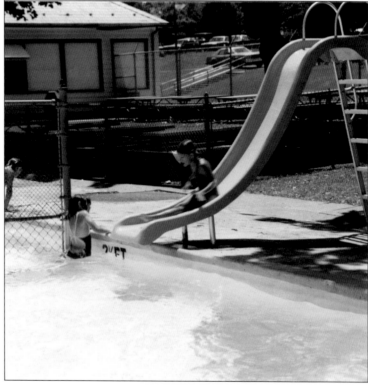

The Coy family enjoys the pool on July 4, 1983. (Catasauqua Public Library.)

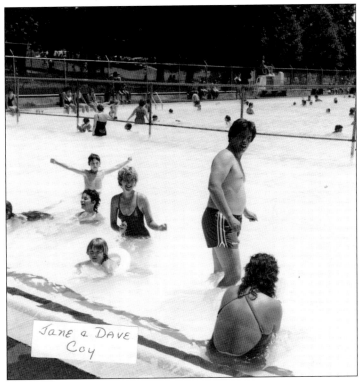

Jane a Dave Coy

The lifeguard in this undated photograph is holding someone's hat and glasses while she chats with her friends. Older residents will remember these narrow iron lifeguard stands. (Catasauqua Public Library.)

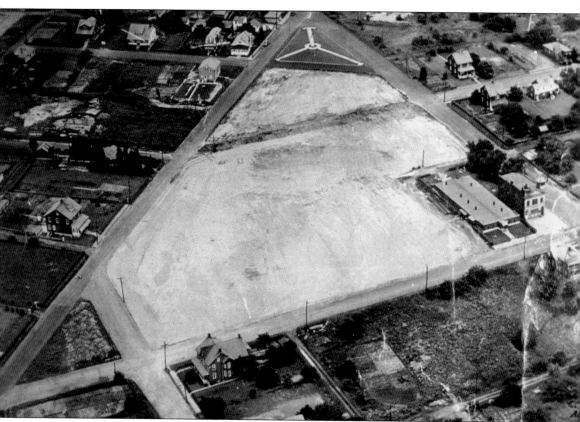

This aerial view of the site of the North Catasauqua playgrounds was taken in 1945. The War Memorial, dedicated in July of that year, is at the top of the triangle. North Catasauqua purchased the four-acre site from the county for $311.62; it had reverted to Northampton County when the failed Lackawanna Land Development Corporation defaulted on property taxes. The 95 sycamore trees that line the perimeter of the park were planted in the spring of 1947, and the park was dedicated (though the ceremony was moved indoors because of bad weather) on June 14 of that year. The Porter Lodge (then the Charotin Social Hall) and the Charotin Fire Company are in the lower right corner of the tract. (Historic Catasauqua Preservation Association.)

Six

FACES AND PLACES

This chapter is a sort of "family album" of the boroughs. The pictures here span the 20th century and feature some famous faces, many familiar ones, a few businesses that are long gone, a few that are still around, and some street views that show how much has changed—and also how little some things have changed. The photographs on nine of the last 10 pages of this book were taken by the author on a ramble through town on the morning of July 4, 1990—the 150th anniversary of David Thomas's first successful iron blast. He would be amazed—and delighted, it is hoped—by what he had wrought on the banks of the Lehigh.

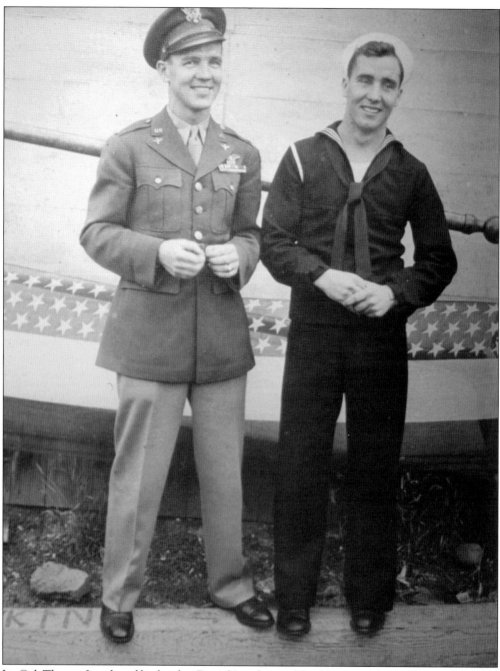

Lt. Col. Thomas Lynch and his brother Daniel Lynch posed for this picture during "Tommy" Lynch's leave from the US Army Air Corps in the fall of 1943. (The brothers grew up in the family home at 426 Walnut Street.) By that time, Lynch, aged 26, was a highly decorated fighter pilot. Flying P-38s in the Pacific, Lynch was the war's first ace, shooting down 20 Japanese planes. Offered retirement in January 1944, Lynch refused, returned to the Pacific, and was killed during a bombing run over New Guinea on March 8, 1944. (Historic Catasauqua Preservation Association.)

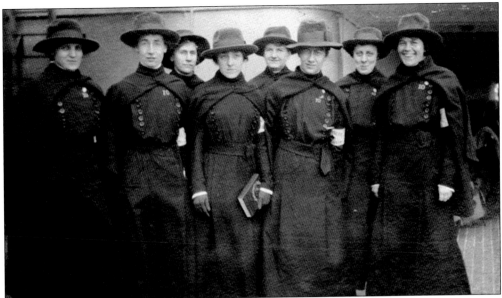

Utie Kleibscheidel (fourth from left) graduated from Catasauqua High School in 1909. Interestingly, she grew up on the same block as Tommy Lynch, at 418 Walnut Street. In the photograph above, she and her fellow Army nurses of the Mobile Unit No. 8 are aboard the TSS *Rotterdam*, either en route to France or homeward bound in 1918. Nurse Kleibscheidel was one of the first women to reach the rank of lieutenant colonel in the Army, a rank she attained during World War II. (Catasauqua Public Library.)

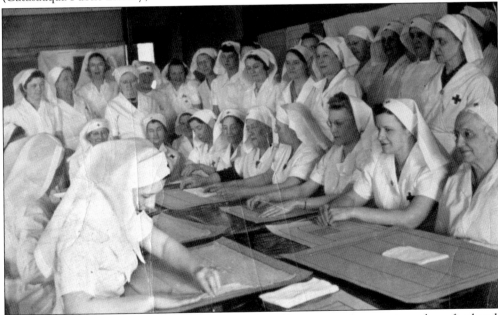

Utie Kleibscheidel was probably the only woman from Catasauqua who experienced war firsthand. Her photograph album from France shows the devastation that the war had wreaked on that country. But the women at home supported the war effort in many ways. The picture above shows the Red Cross ladies preparing bandages for use in field hospitals. (Historic Catasauqua Preservation Association.)

The Catasauqua Club was chartered in 1897. It has always been quartered in the Morgan Emmanuel house at 226 Pine Street, which the club purchased in 1900. The original member roster included most of the prominent men of the borough at that time, including Leonard Peckitt, president of the Empire Steel and Iron Company, James W. Fuller and his son "Colonel" James Fuller, William Thomas Sr. and Jr., Bryden Horse Shoe Works president George Holton, and David Thomas's son-in-law Joshua Hunt. This photograph may have been taken in 1914, during Old Home Week. (Catasauqua Club.)

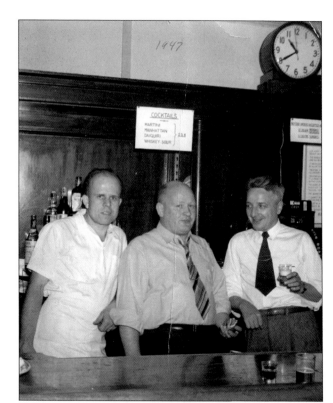

Harold Heffelfinger (left), Willard Crock (center), and Ed McNabb chat behind the bar at the Catasauqua Club in 1947. Membership had its privileges—the price of drinks was low, even for that time. Below is the barroom as it appeared in the 1940s. (Both, Catasauqua Club.)

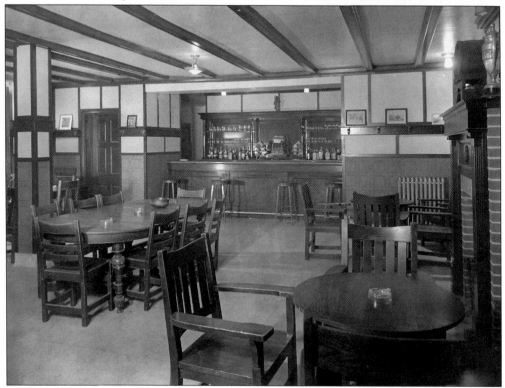

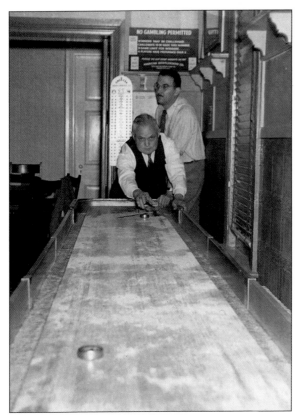

Shuffleboard was a regular pastime for club members. In the photograph at left, Harvey Rinker is intent on his play, despite the hovering presence of Carl Mark. Below, Anna Burkholder hones her shuffleboard skills. (Both, Catasauqua Club.)

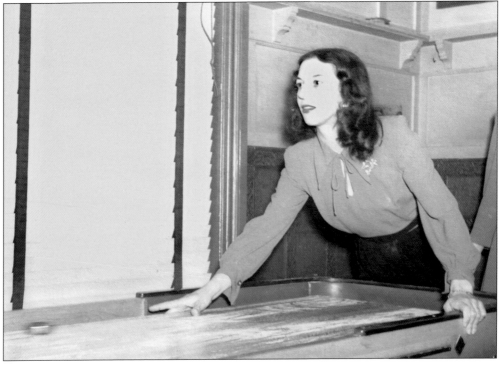

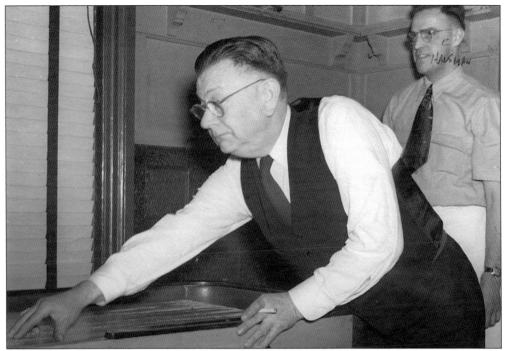

A friendly rivalry among the doctors pits Dr. Harry L. Baker (above) against Dr. H.J.S. Keim (below). Gone are the days when a physician would be photographed with a cigarette in hand! (Both, Catasauqua Club.)

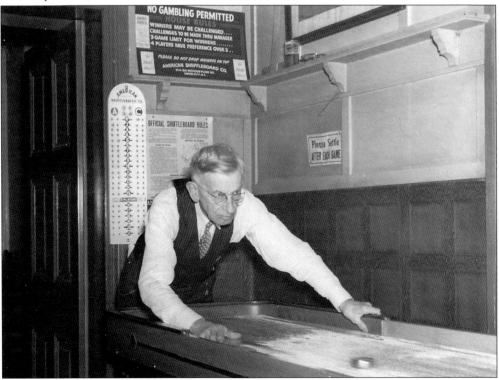

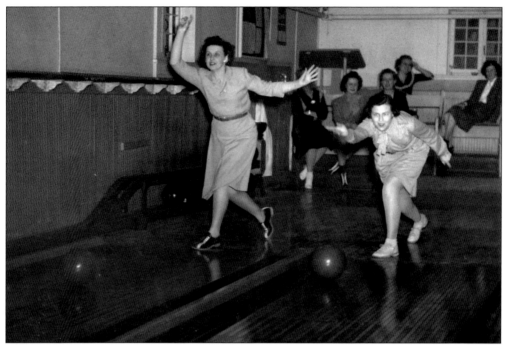

Though the club was originally exclusively for men, there were female members by the time the club celebrated its 50th anniversary in 1947. The club offered bowling leagues, which played intramural matches in the two-lane alley in the basement. In the photograph above, Caroline Thomas (left) and Ruth Grazier (right) roll off against each other. Below, members of the ladies league wait their turn. Note that changing to bowling shoes was their only concession to "dressing down." (Both, Catasauqua Club.)

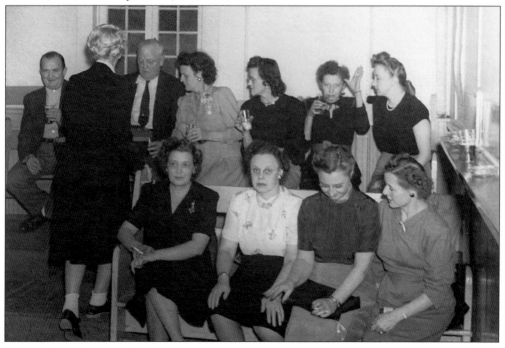

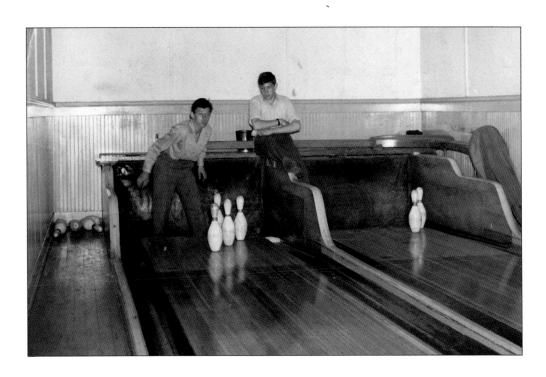

The names of the two pinsetters above are unknown, but it was a much desired after-school job for teenage boys. Less strenuous club activities involved friendly games of cards. Below, George Hefele (left) and three unidentified men play a round. (Both, Catasauqua Club.)

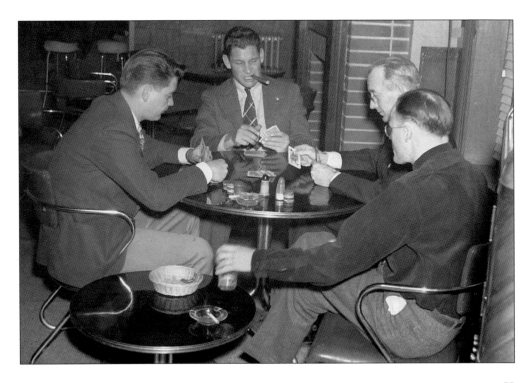

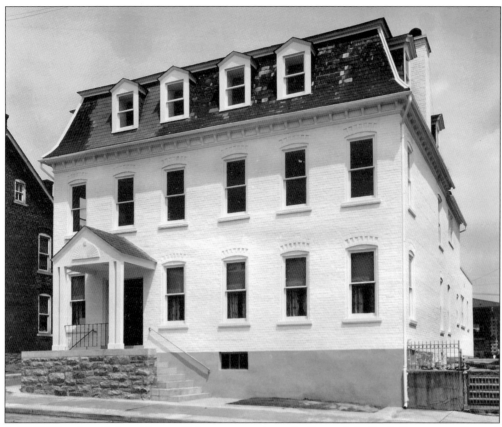

In 1943, Theodore Geiger relocated his restaurant from the front of the Eagle Brewery on Second Street to his home on Howertown Road (above). This necessitated major exterior and interior changes to the house, which were recorded in these pictures, taken before the restaurant opened for business. The photograph below shows the small front dining room—now the Colonial House restaurant—which still looks much the same nearly 70 years later.

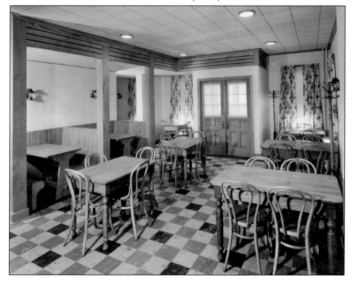

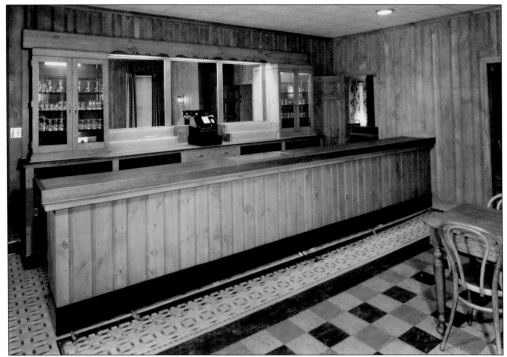

Above, the bar is also little changed, though in 1943, no one dreamed of that now-required barroom fixture the television. The stove in the photograph below was still in use when Theodore's son Stephen sold the restaurant in 1969, but the wooden refrigerator was on a different wall, the dishes stood on shelves on the table, and there was a large counter and a two-tub dishwasher in the corner to the right.

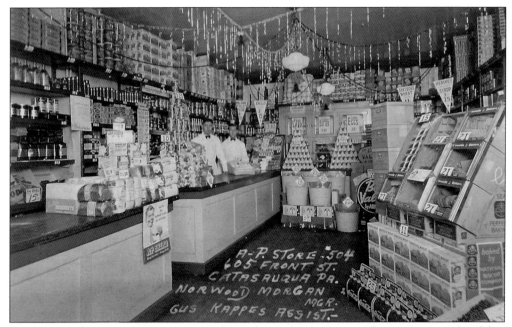

Catasauqua's first A&P grocery store was located at 605 Front Street. This picture is undated, but it must have been taken after 1912, as A&P did not start to open its "economy" stores until that year. The two men in the picture are Norwood Morgan, who was the manager, and Gus Kappes, who was the assistant. (Catasauqua Public Library.)

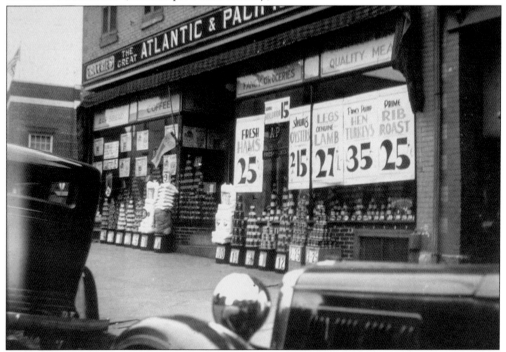

The year that the A&P moved to its longtime location at Second and Bridge Streets is not known. The post office, visible on the left, indicates that the picture was taken after 1935. (Historic Catasauqua Preservation Association.)

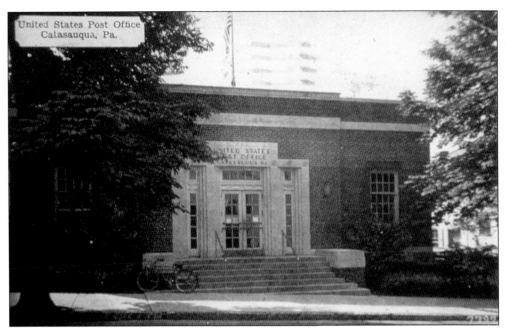

The intersection of Second and Bridge Streets truly became the hub of "downtown" Catasauqua when the post office moved from 120 Bridge Street, a building now gone, to the current location. The 1935 post office was part of the federal government's building program to employ workers displaced by the Depression. The building features *Arrival of the Stage*, a mural by F. Luis Mora, whose government contract to paint, travel to Catasauqua, and install the mural paid all of $780. In the photograph below is a view of the intersection, looking east up Bridge Street, taken on July 4, 1990. (Above, Catasauqua Public Library.)

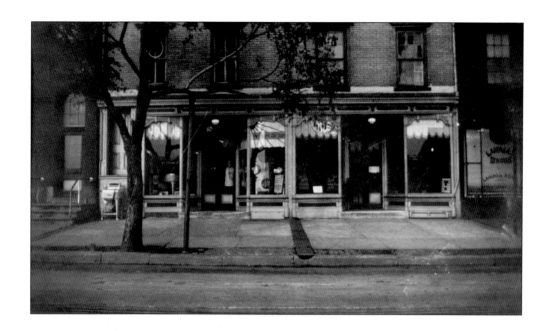

In the early 20th century, Kleppinger's Front Street store (above) became Catasauqua's favorite place to buy every newfangled electric-powered item that became available. The savvy merchant even put new washing machines out on the sidewalk to tempt shoppers and people passing by on the streetcar. (Both, Historic Catasauqua Preservation Association.)

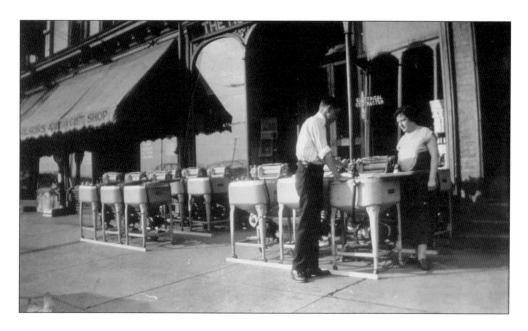

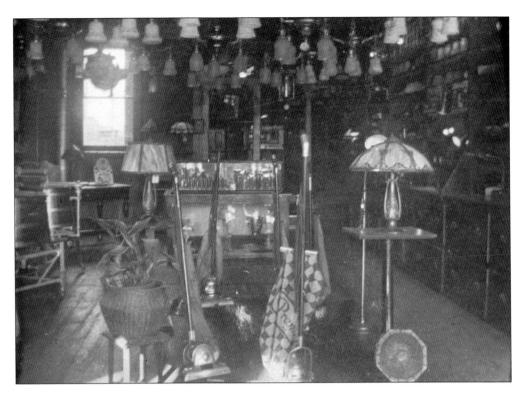

This interior shot (above) shows part of Kleppinger's extensive stock, which included vacuum cleaners, space heaters, and lamps of all descriptions. Though there were stores up and down Front Street and scattered throughout town, this block of Front Street between Church and Bridge Streets was the main shopping district, anchored by Miller's Store at Church Street and including Lawall's Drug Store. (Both, Historic Catasauqua Preservation Association.)

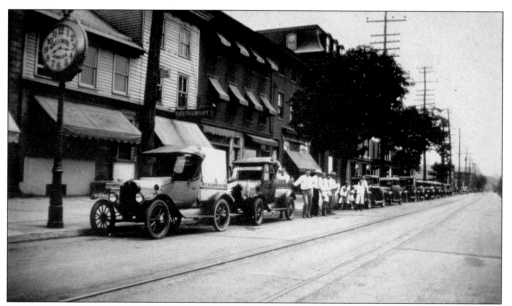

This picture shows the northern end of the same block of Front Street, including the Mansion House Hotel and Beitel's Jewelry Store. Notice that there was already an abundance of cars in town by this time. (Historic Catasauqua Preservation Association.)

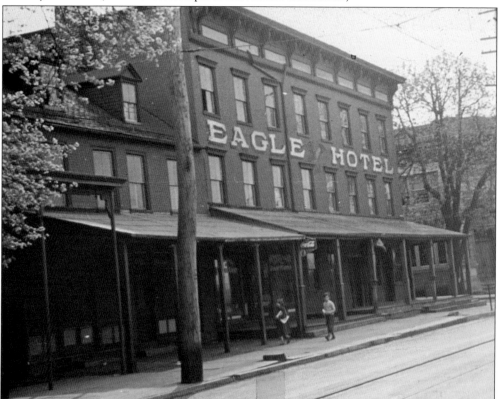

The Eagle Hotel, the second oldest in Catasauqua, still welcomed guests at the corner of Bridge and Front Streets until the early 1930s. (Historic Catasauqua Preservation Association.)

JOHN P. SCHNELLER,

DEALER IN

Stoves, Ranges, Tinware, &c,

Practical Worker in Tin, Sheet Iron, Copper, &c.

Repairing Done at Short Notice by Practical Workmen.

CATASAUQUA, PA.

The large building that still stands at Front and Strawberry Streets was known as Schneller's Block, because it was built by Charles Schneller and owned by his family for at least three generations. The Schnellers were tinsmiths and metal workers, who, as the business advertising card above shows, specialized in heating and cooking stoves, which they sold from their store. By the 1930s, a member of the family had branched into more general merchandise, as this interior shot of the What Not Center and Gift Store at 515 Front Street shows. (Above, Catasauqua Public Library; below, Historic Catasauqua Preservation Association.)

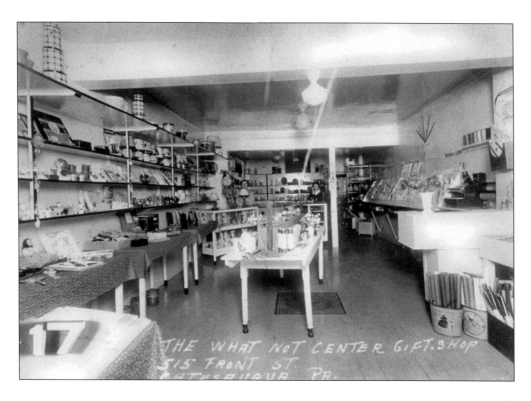

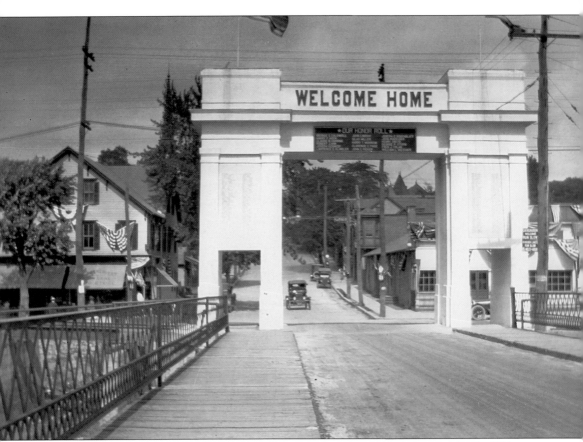

The Memorial Arch at the Front Street end of the Pine Street Bridge was erected for the Welcome Home celebration when the town's residents who had served in World War I returned home. The words "Heckenberger's Rexall Drug Store" can be read on the awnings of the building on the left. This indicates that the photograph was taken some time after September 1920, which was when the pharmacy moved from the location at 145 Front Street where two generations of the family had conducted business since 1874. (Historic Catasauqua Preservation Association.)

Probably from the early 20th century, this advertising card is for Applegate's Store, located at Front and Union Streets. The establishment may have either predated George Deily's store at that location or shared the space. (Catasauqua Public Library.)

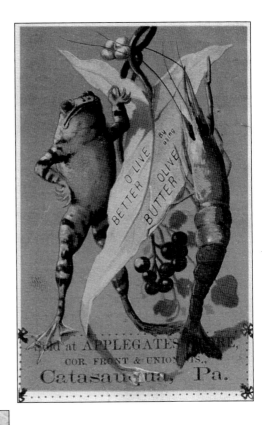

Mennonite Brethren in Christ

Sunday School,

N. W. Cor. 3rd & Chestnut Streets,

CATASAUQUA, PA.

A hearty invitation is hereby extended to you to attend our Sunday School and other services.

SERVICES :

Sunday School, — — —	1.45 P. M.
Prayer Meeting, — —	3.15 P. M.
Prayer Meeting, Wednesday,	7.30 P. M.
Preaching, Saturday, — —	7.30 P. M.

"I was glad when they said unto me, Let us go into the house of the Lord."—Psalm 122; 1.

REV. O. HILLEGAS, Pastor.

A. GAUMER, Supt.

The 1876 map of Catasauqua shows a Welsh Methodist church occupying the address to which this postcard from the Mennonite Brethren in Christ was inviting visitors. Since there are no known existing records of either congregation, the date of this postcard can only be guessed to be the early 20th century.

What To Do With
Your Four Or
Five Year Old

PRIVATE KINDERGARTEN

RUTH D. MILSON

Ruth Milson's kindergarten is the only private school known to have been established in Catasauqua. "Miss Ruth" started her school for four-and-five-year-old children in the spacious third floor of her home at 533 Third Street in the 1930s. The niece of Minnie Milson Thomas, she shared her aunt's ideals for the education of young children and set out the arguments for kindergarten inside this brochure.

TERMS UPON REQUEST

School year is from middle of September to June.

Daily session is from nine to eleven-thirty.

During a child's illness, regular rates will continue except in cases of prolonged illness, when reasonable allowance will be made to the parent or guardian.

For further information kindly apply to

RUTH D. MILSON
533 Third Street
Catasauqua, Pa.

Phone Catasauqua 119-M

Earl Roth directed the Catasauqua High School band for many years. Here he is shown outside the American Legion post on Second Street. (Historic Catasauqua Preservation Association.)

On Memorial Day, 1937, Catasauqua's last living Civil War veteran, James C. Beitel (third from left), then 97 years old, participated in the ceremonies at the Civil War monument in Fairview Cemetery. With him are Dr. Harry Baker (left) and Morris S. Schifreen (right), both past commanders of the Legion post, and Gen. F.D. Beary, who was the speaker for the ceremony. (Catasauqua Public Library.)

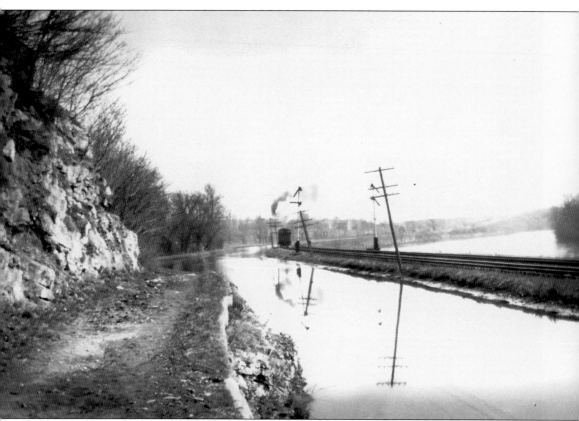

A Central Railroad of New Jersey (CNJ) train steams south from Catasauqua some time around 1920. At various times, seven different railroads either passed through Catasauqua itself or served it from the other side of the Lehigh River: the CNJ, the Lehigh & New England (LNE), and the Crane Iron's short line operated in Catasauqua and North Catasauqua, while the Lehigh Valley Railroad (LV), the Philadelphia & Reading Railroad (P&R), the Catasauqua & Fogelsville Railroad, and the Ironton Railroad tracks were all on the opposite banks of the river. Today, the last active tracks lie on the CNJ right-of-way between the canal and the river. (Historic Catasauqua Preservation Association.)

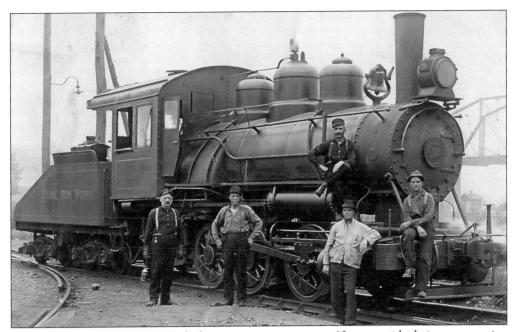

The crew of the Crane Iron Works locomotive seen on page 10 poses with their steam engine near the Pine Street Bridge in this undated photograph. The only person who has been identified is Jim Desmond, second from the left. (Catasauqua Public Library.)

LNE locomotives cross the Fuller Company property, probably en route to the trestle, some time in the early 1960s. The LNE had abandoned all its track though the borough by 1964. (Historic Catasauqua Preservation Association.)

On the back of this undated photograph of this charming little house is a note that reads, "House on Chapel Street, note the water tower in background." But where this house was, when this picture was taken, who the lady on the porch is, and which company's water tower are all unknown. (Catasauqua Public Library.)

The front yards of 540 and 546 Fourth Street, with Holy Trinity Lutheran Church's tower in the background, appear in this black-and-white study of shape and texture made in 1988.

A member of the Somers family shot this snow scene of the Dery Mansion from the front porch of their home at 545 Howertown Road. This photograph was taken around 1920, after the house had been greatly expanded. A domed astronomical observatory, which let D.G. Dery scan the heavens, is on the roof. (Historic Catasauqua Preservation Association.)

The Mark house, at 703–705 Howertown Road, still stands at the corner of Walnut Street and retains the original porches. The girl on the left appears to be holding a monkey. (Catasauqua Public Library.)

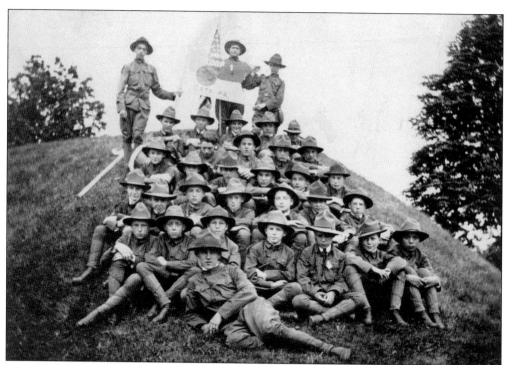

Catasauqua Boy Scout Troop No. 1 is on an outing, possibly a camping trip, in Lyons Valley in 1916. (Catasauqua Public Library.)

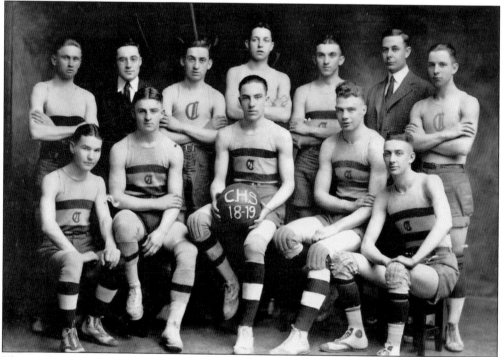

This is the 1919 Catasauqua High School basketball team, wearing heavy, laced-up shorts. (Catasauqua High School.)

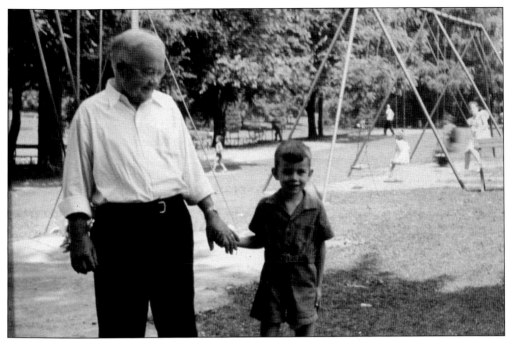

A young boy and his grandfather enjoy the Catasauqua playgrounds together in this photograph, taken in the late 1940s. (Historic Catasauqua Preservation Association.)

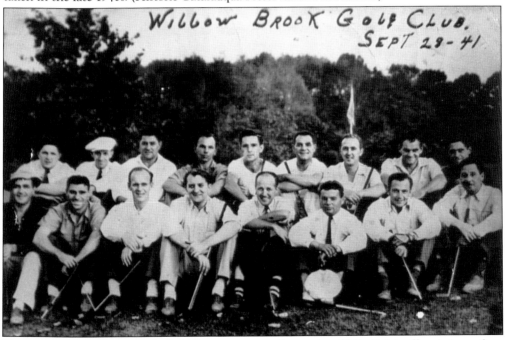

Players at the Willow Brook Golf Course pose in September 1941. Originally a private five-hole course built by Col. James Fuller on his Willow Brook Farm estate, it was expanded to a nine-hole, members-only club (for a yearly fee of $44!) in 1932. But economics dictated the club going public, and in 1934, it became only the second public golf course in the Lehigh Valley. (Catasauqua Public Library.)

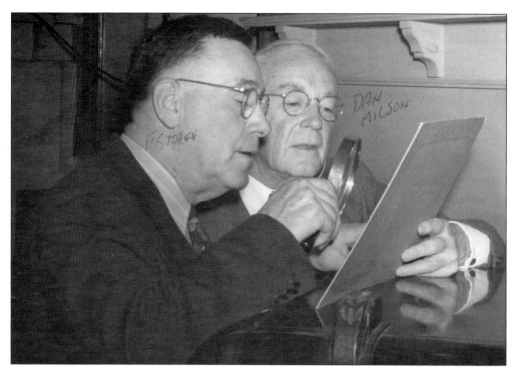

These two pictures were taken during the Old-Timers Night event of the Catasauqua Club's 50th-anniversary celebration in November 1947. In the photograph above, Fritz Storch (left) and Dan Milson closely examine an old picture. Below, from left to right, Charles Kiesbar, Catherine Fatzinger, and Joe Gaffney pose for a picture. (Both, Catasauqua Club.)

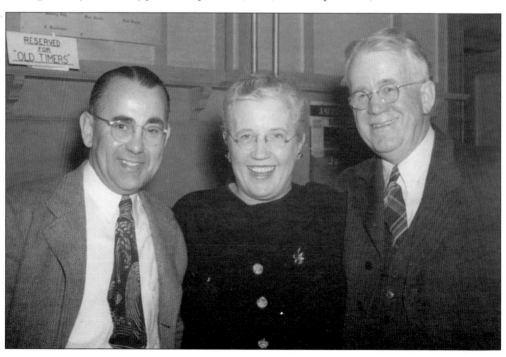

A business advertising card from the 1950s (above) touts the benefits of having an Esther Williams–endorsed swimming pool in the backyard. The A. Newton Bugbee contracting firm was licensed to construct them. With his trademark cigar, owner A. Newton Bugbee Sr. chats with Harleigh Fatzinger and an unidentified man at the Catasauqua Club's father-and-son night. (Above, George Kraynick; below, Catasauqua Club.)

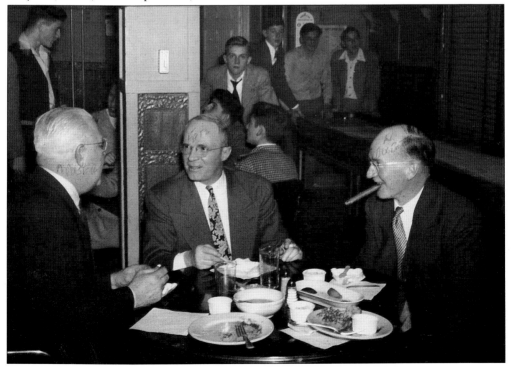

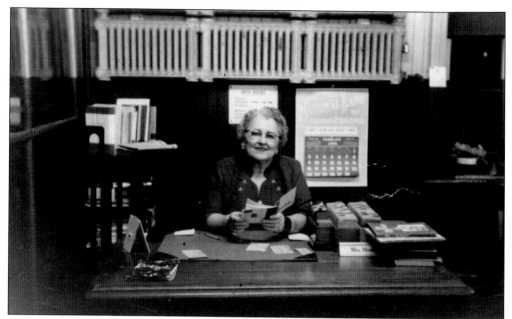

Margaret Moat was the librarian at the Catasauqua Public Library from 1951 to 1967, the second longest tenure of any librarian since it was begun in 1924. (The current librarian, Martha Birtcher, has held the post since 1982.) This photograph dates from 1958, when the library occupied only the basement of the building, and the main floor of the former Holy Trinity Lutheran Church was rented by the Catasauqua Women's Club. (Catasauqua Public Library.)

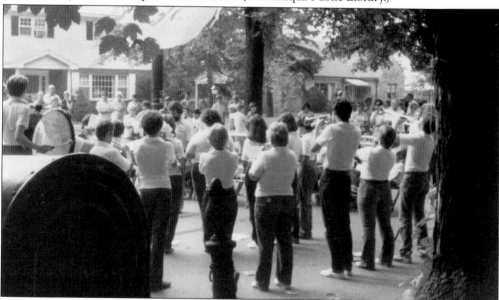

The Friends of the Library began holding block parties to raise money for the library in 1979. These annual September fundraisers became eagerly awaited community events, which, like the J4 celebrations, were opportunities for local organizations to raise money for themselves as well as the library, for flea marketers and local crafters to sell their wares, and for community groups and public-spirited folks to pitch in. In this photograph, the high school band plays on Bridge Street, near Howertown Road. (Catasauqua Public Library.)

Rotarians John Brubaker (left) and Raymond Reed are at a stand at Fourth and Bridge Streets at the 1980 Block Party (above), while Catasauqua Garden Club members Betty Labenberg (left) and Elsie Reed (front, center) smile from the club's live and dried plant table in front of Dr. Antonio Almazan's office and home. (Both, Catasauqua Public Library.)

Dr. John Peterman and Louann Peterman (left) always cheerfully participated in many ways with the block party, which took place in front of their house. Cliff (left) and Janice (center) Lathrop and Catherine Quinn were busy making funnel cakes at the 1980 event. (Both, Catasauqua Public Library.)

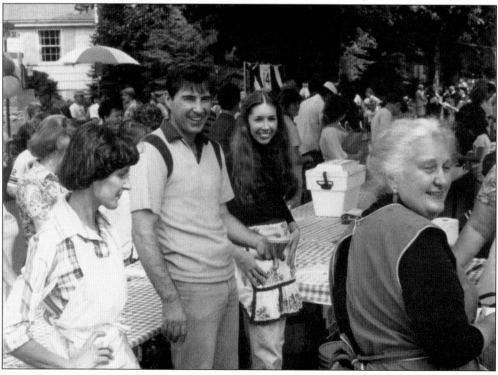

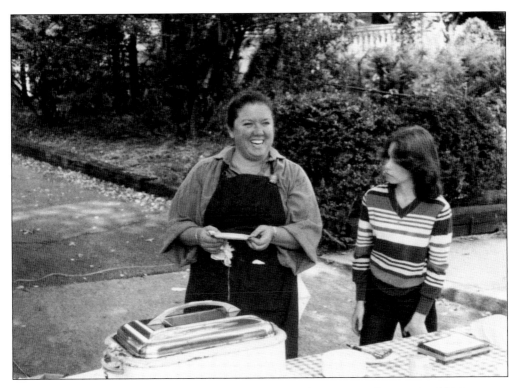

Cy Carlson (above) and her famous stuffed shells were always a popular stand at block parties, while below, Peg Delong (left) and Edith Bartholomew (right) could always be found staffing the flea market tables. (Both, Catasauqua Public Library.)

Nancy Davidson (left) displays crafts in front of 330 Bridge Street during the 1980 Block Party, while Jan McKittrick (below right) and an unidentified woman smile behind the mums and other plants on Fourth Street. (Both, Catasauqua Public Library.)

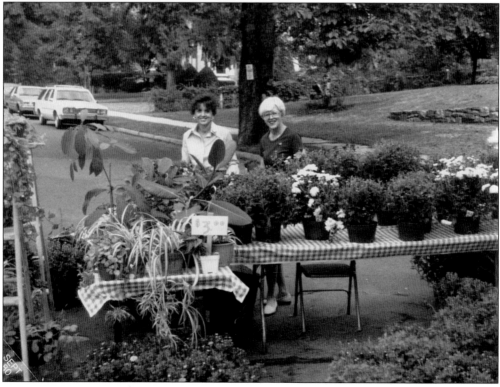

Sharon Quinn Nogales (left) and Dolores Decker, the organizers of the 1980 Block Party, smile on the sidewalk in front of 306 Bridge Street (right) as everything comes off without a hitch. Elias "Grimmy" Grim displays his antiques and his considerable knowledge near St. Paul's parsonage during the first block party in 1979 (below). (Both, Catasauqua Public Library.)

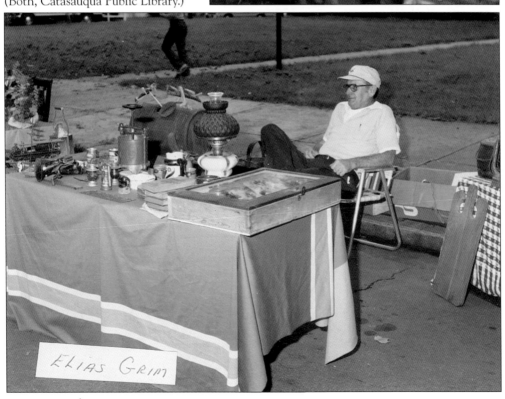

ELIAS GRIM

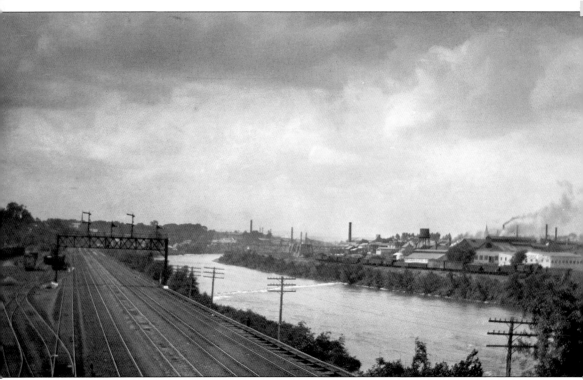

An outstanding view, taken from the west side of the Pine Street Bridge about 1920, shows the tracks of the Lehigh Valley, Catasauqua & Fogelsville, and Ironton Railroads, the Lehigh River, a train on the Central Railroad of New Jersey tracks, and the Bryden Horse Shoe Works. In the distance, the Hokendauqua Bridge can be discerned, as well as the trestle, which still crosses the canal bed just below that bridge. The distant smoke is probably from the Atlas Cement plants in Northampton. (Historic Catasauqua Preservation Association.)

A loving cup was presented to George Holton, president of the Bryden Horse Shoe Works, by the employees "to show our appreciation of his many favors to us." Unfortunately, the date of this presentation is not known, but Holton died in 1913 at the age of 45. (Catasauqua Public Library.)

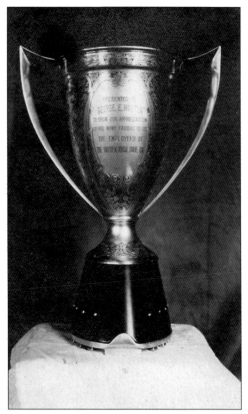

Two trucks loaded with children in costume and flags waits to step off for an Old Home Week parade in front of the Bryden Horse Shoe Works on upper Front Street in 1914. (Catasauqua Public Library.)

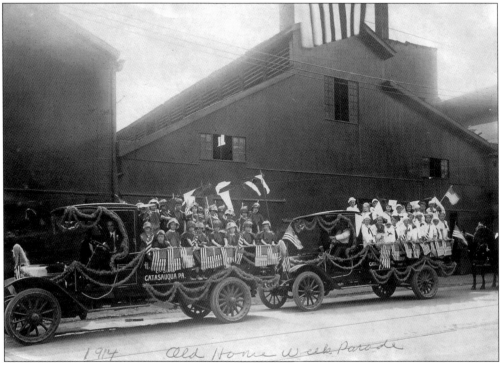

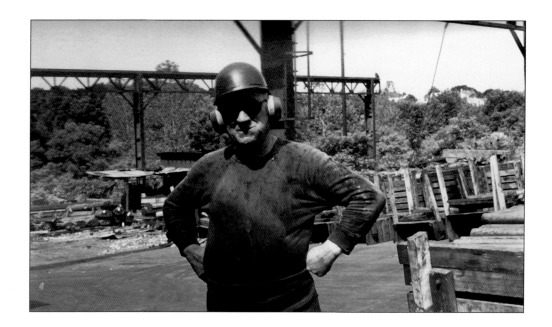

Phoenix Forging Company is now both boroughs' last link to their industrial past. The firm still operates at 800 Front Street in North Catasauqua, where the Bryden Horse Shoe Works was built on Paul Faust's farm along the canal during the 1880s. The photographs of Phoenix workmen here and on the next two pages were taken in the plant during the 1970s by Jack Molchan. Mike Guzy is pictured above, and Will Arner is below. (Both, Larry Tait.)

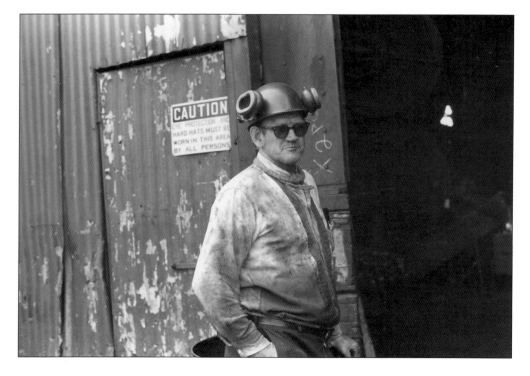

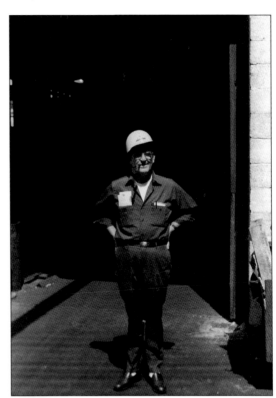

Foreman Bill Chadwick takes a pipe
break at right, while legendary tough guy
"Joe the Shoe" Durancinski pauses for
a cigar and a drink. (Both, Larry Tait.)

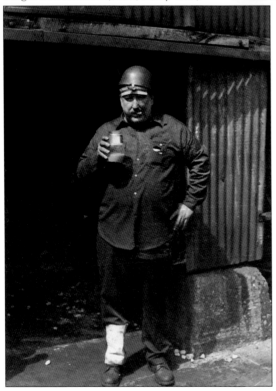

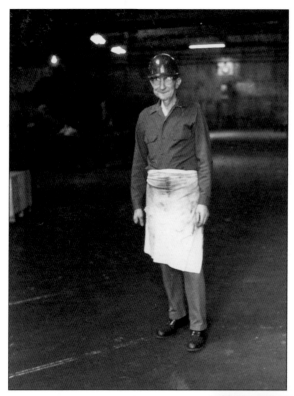

Steve Shumack hardly seems burly enough for forging work (left). Ed Almond (below) takes a breather from the hot, noisy, dirty work that forging entails. (Both, Larry Tait.)

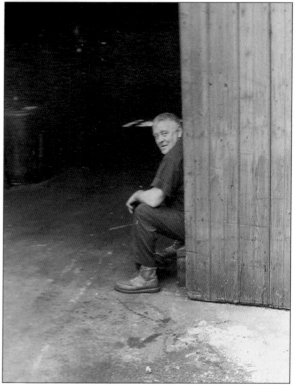

This advertising card dates from the period in the 1920s when Phoenix had taken over the Bryden but had not yet consolidated all its works in North Catasauqua. It was still making horseshoes and shoeing apparatus; the reverse side of this card lists all the available sizes of toe calks.

PLAIN NIB

PHOENIX

TOE CALKS

BLUNT—COUNTRY—SHARP

Manufactured by

PHOENIX
HORSE SHOE CO.

Rolling Mills and Factories

JOLIET, ILLINOIS POUGHKEEPSIE, N. Y.

CATASAUQUA, PA.

The house at 1021 Front Street, across from the Phoenix Forge, is part of a row of houses between Almond and Arch Streets that was built by David Thomas's Catasauqua Manufacturing Company to house workers in the mid-1860s. These tiny but sturdy brick dwellings once housed surprisingly large groups of single men, but now, like virtually all the former company houses in the boroughs, are family homes.

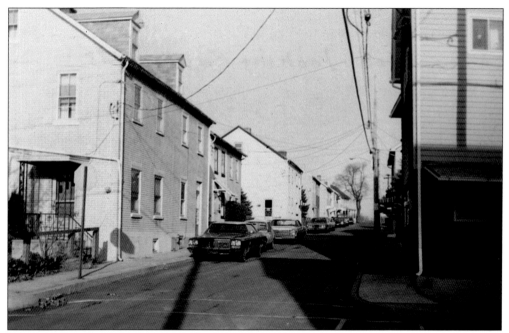

Catasauqua and North Catasauqua have what is probably the largest still-occupied collection of 19th-century company houses in Pennsylvania and possibly the United States. These modest houses are as historically significant as the mansions and industrial ruins in the boroughs. The loving care most residents have lavished on their houses means that very few retain much of their original appearance, but the fact that they still stand testifies to the strength of both communities and should be a point of pride for everyone who lives in them. Above, Wood Street, near Second Street, appears as it looked in 1983, and below is Church Street, up from Second Street, in 1971.

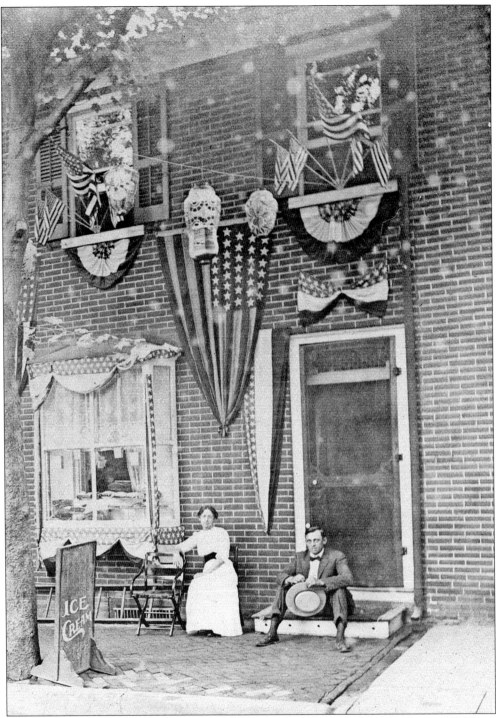

This never-before-seen photograph of 216 Church Street was probably taken during Old Home Week in 1914. At the time, these residents operated a bakery from their home, and they were trying to add to their trade with ice cream. The flag hanging from the second story has 36 stars, which means it dates from 1864 to 1866. (Faye Westover.)

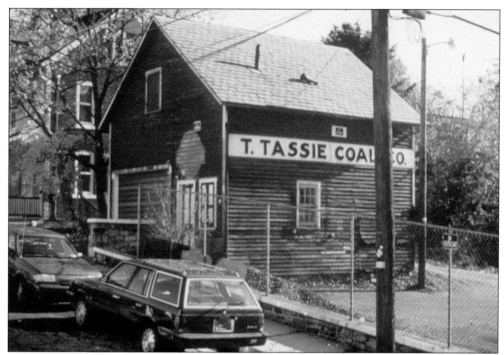

The coal yard along the Lehigh Canal appears above, still bearing the Tassie name in the late 1970s. Originally operated by George Deily, whose house stands along the canal closest to the smaller bridge. The coal yard and the former Lehigh Coal and Navigation Company's mule barn (below) are now part of the canal-front property maintained by Historic Catasauqua Preservation Association (HCPA). (Both, Historic Catasauqua Preservation Association.)

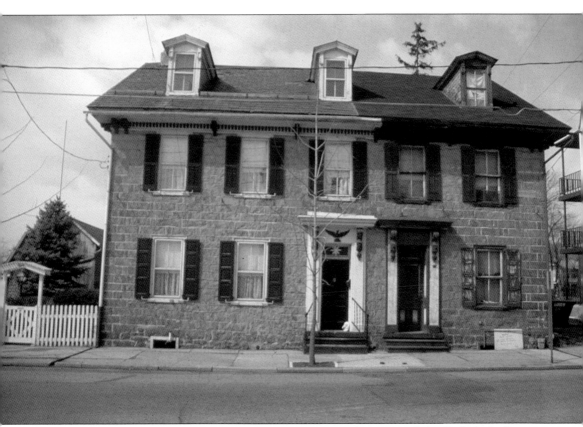

HCPA grew out of an architectural survey of the mansions that was made by the Lehigh County Historical Society in the 1970s. In 1983, a small group of residents got together to prepare applications for two national historic districts in Catasauqua, the Biery's Port and Mansion Districts. The Biery House and Museum, at 8 Race Street, which dates to 1826, is now the association's headquarters and museum and includes an art gallery of paintings, drawings, and prints by local artists that depict houses, historic sites, and people from the towns. (Historic Catasauqua Preservation Association.)

Restaurant owner Wilbur Hill Sr. is shown with his children Wilbur "Will" Jr. and Faye in these photographs, taken shortly after the Hills took over Frank's restaurant, on Bridge Street, in 1955. (Both, Hill family.)

Pat Kelly, Catasauqua High School class of 1985, was drafted by the New York Yankees in 1988 and played second and third base with the Yankees for seven seasons (1991–1997), the 1998 season as a St. Louis Cardinal, and part of the 1999 season with the Toronto Blue Jays. Now a resident of Australia, where baseball is slowly growing in popularity, he is an assistant coach with the Australian national team. (Catasauqua Public Library.)

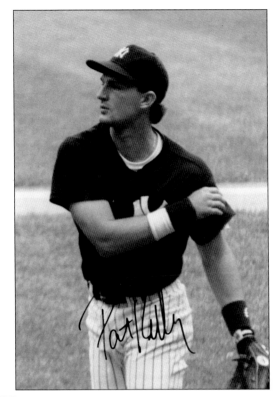

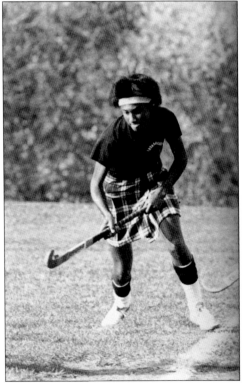

Debbie Linton, Catasauqua High School class of 1984, was an outstanding athlete in a class that boasted several. She reached the statewide level of competition in all four years of high school, capping off her career with a victory in the 300 hurdles in her senior year. She was also captain of the field hockey team, which won the Colonial League championship in 1983, when she led the league in scoring. (Catasauqua High School.)

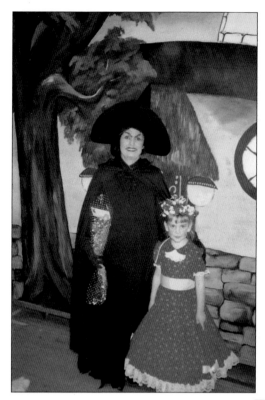

Catasauqua Area Showcase Theatre (CAST) grew out of a group of Sheckler teachers who produced two shows in the early 1990s to raise money for students who were seriously ill. The Sheckler Players then put on *The Wizard of Oz* in 1993, featuring Audrey Heil as the Wicked Witch of the West and Bethany Nothstein as a Munchkin. Below, Sandy Smith played Glinda the Good Witch. (Both, CAST.)

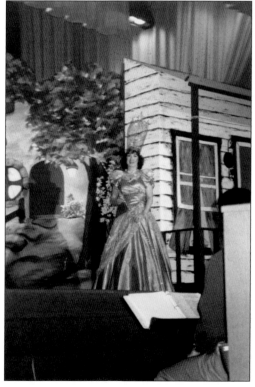

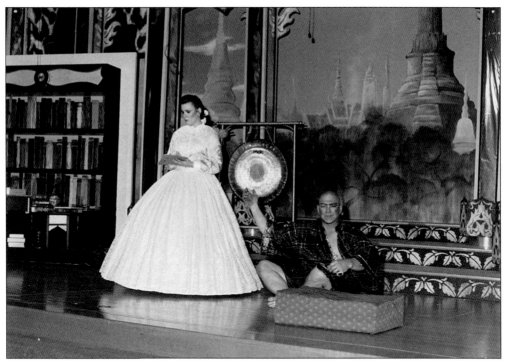

The last show as the Sheckler Players was *The King and I* in 1995. The elaborate backdrop and sets behind Donna Reese, as Anna, and Gene Sebecto, as the King, have become a standard of CAST performances to the present, along with spirited, well-executed performances by both adults and children under the direction of Bill Nothstein and Kathy Meltzer. Below, Amy Givler portrays one of the King's many children. (Both, CAST.)

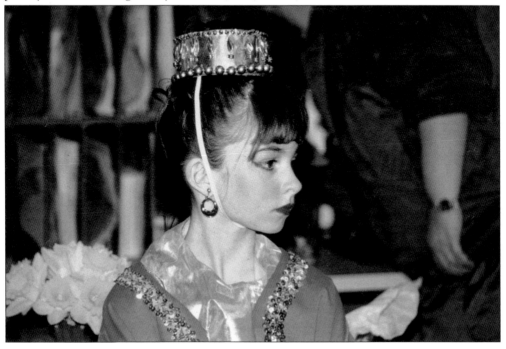

DIRECTORS:-

RUSSELL F. C. BENFER

RALPH C. BOYER

ALFRED E. DOUGLASS

JAMES W. FULLER

ALVIN L. HACKER

H. MORLEY HOLTON

HENRY A. MILLER

R. J. MINNER

HOWARD V. SWARTZ

FRED J. WALKER

THE
NATIONAL BANK
OF
CATASAUQUA

CATASAUQUA, PA.

OFFICERS:

HOWARD V. SWARTZ, PRESIDENT

RALPH C. BOYER,
EXECUTIVE VICE-PRES'T

JOHN J. McCARTNEY
CASHIER

JAMES J. SCHREIBER,
ASST. CASHIER

CHARLES G. ALBERT,
TRUST OFFICER

MEMBER
FEDERAL RESERVE SYSTEM
AND
FEDERAL DEPOSIT INSURANCE CORPORATION

The National Bank of Catasauqua was chartered in 1857 and moved to the location at Second and Bridge Streets in 1904. It remained independent until being acquired by First National Bank of Allentown in the mid-1960s, though it continued to be managed and staffed by local residents for several years after that. This Statement of Condition for 1953 reveals that it had what were then substantial assets for a bank in a small community. The directors listed on the back of the statement (not shown) include bank president Howard Schwartz; vice president Ralph Boyer; Alfred E. Douglass and James W. Fuller, both of the Fuller Company; previous president H. Morley Holton; and R.J. Minner.

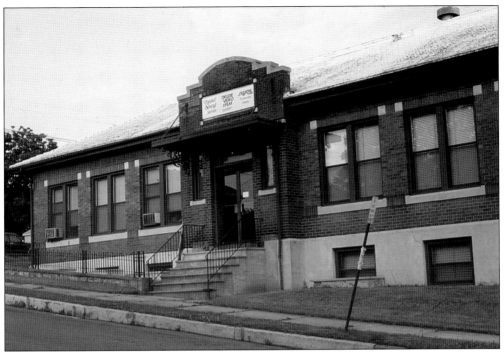

July 4, 1990, was an ordinary Independence Day in Catasauqua, despite being the 150th anniversary of David Thomas's first successful blast in his anthracite-fired iron furnace. The author took a long walk around town that morning to record how it stood a century and a half after Father Thomas started it all. Above is the former headquarters of the Bryden Horse Shoe Works, and below is Front Street near Chapel Street.

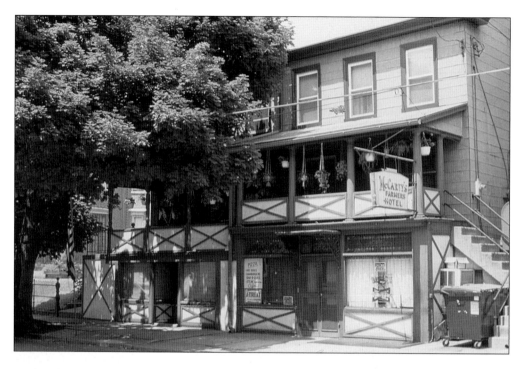

In the above image is McCarty's, which has been in business at this address since the 1880s. Below is 717 Front Street, frequently pictured in old photographs as the headquarters of the famed Hanna Athletic Club.

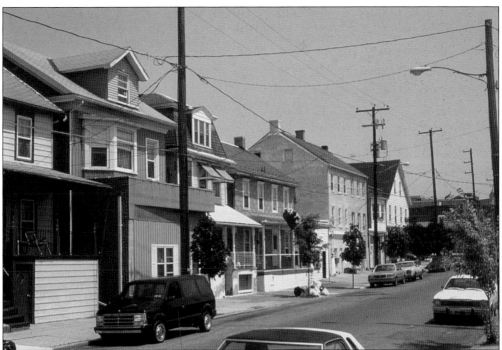

Above is Front Street, south of Walnut Street. The former Odd Fellows Hall (the original Grace Methodist Church), built in 1865, appears at right, with the Fuller family's first home in the background.

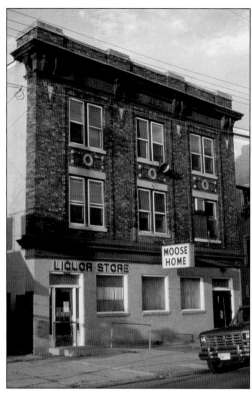

At left is the former Junior Mechanics building, which housed the Moose Home and the Liquor Store in 1991, and below is the building that formerly was the Masonic Hall and housed Beitel's Jewelry Store at 511 Front Street.

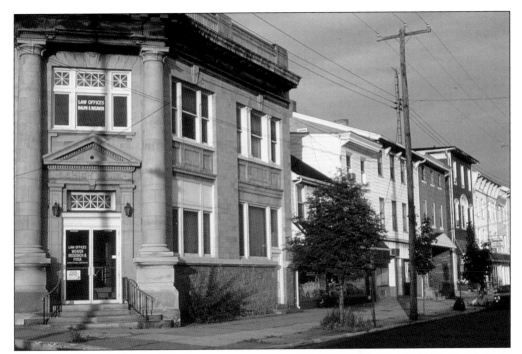

The former Lehigh National Bank, built in 1910, was soon to be become the Lehigh Valley Acupuncture and Oriental Medicine Center. Drs. David and Ming ming Molony, who are internationally recognized for their practice, have also made the building their family's home.

The building currently owned by the Catasauqua Community Thrift Store has a long and varied history. It was the offices and print shop of the *Catasauqua Dispatch* from about 1890 to 1952, and then it became Mark's store for gas stoves and appliances. After brief stints as a sculptor's studio and a running shoe store, the thrift store was established there in the 1980s.

123

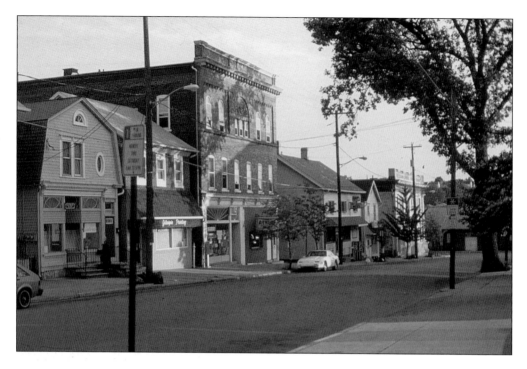

The south side of Bridge Street, from Hutterer's barbershop to Front Street, appears as it looked on July 4, 1990, above. Below is a view of Second Street, looking south from Walnut Street, with the Presbyterian church in the background.

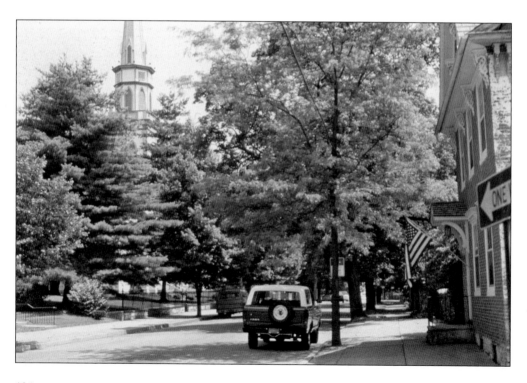

Candy Cane Park, formerly the site of Catasauqua's (and Lehigh County's) first high school, appears above. Below is Leonard Peckitt's former residence in the foreground at Third and Walnut Streets, then and still the Brubaker Funeral Home (below).

At left is the Fifth Street entrance of the Dery Mansion, the home of Albert Moffa and his family in 1990, and below is David Thomas's Presbyterian church at Second and Pine Streets.

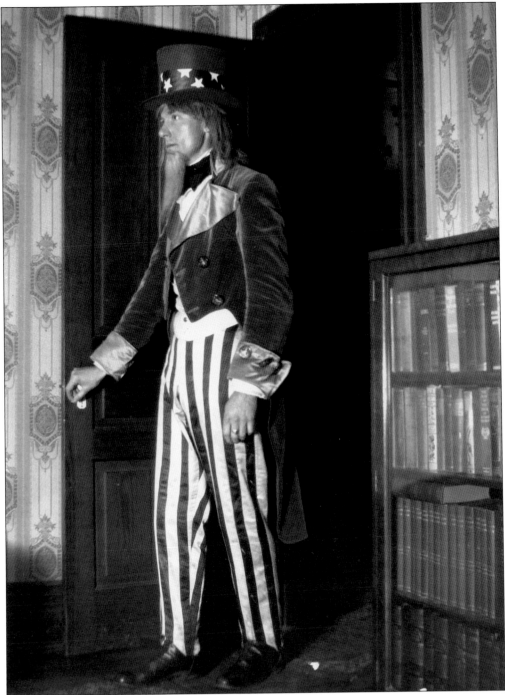

Eugene Somers was photographed in the living room of his family's home at 454 Howertown Road. He was dressed to portray Uncle Sam in the *Victory Cantata* on December 31, 1918, and January 1, 1919. Nothing is known about this event, but it was most certainly held to celebrate the end of World War I. (Historic Catasauqua Preservation Association.)

www.arcadiapublishing.com

MAP SEARCH

Discover books about the town where you grew up, the cities where your friends and families live, the town where your parents met, or even that retirement spot you've been dreaming about. Our Web site provides history lovers with exclusive deals, advanced notification about new titles, e-mail alerts of author events, and much more.

Arcadia Publishing, the leading local history publisher in the United States, is committed to making history accessible and meaningful through publishing books that celebrate and preserve the heritage of America's people and places. Consistent with our mission to preserve history on a local level, this book was printed in South Carolina on American-made paper and manufactured entirely in the United States.

This book carries the accredited Forest Stewardship Council (FSC) label and is printed on 100 percent FSC-certified paper. Products carrying the FSC label are independently certified to assure consumers that they come from forests that are managed to meet the social, economic, and ecological needs of present and future generations.

FSC
Mixed Sources
Product group from well-managed
forests and other controlled sources

Cert no. SW-COC-001530
www.fsc.org
© 1996 Forest Stewardship Council

Find Your Place in History.